MAP ART LAB

Brimming with creative inspiration, how-to projects, and useful information to enrich your everyday life, Quarto Knows is a favorite destination for those pursuing their interests and passions. Visit our site and dig deeper with our books into your area of interest: Quarto Creates, Quarto Cooks, Quarto Homes, Quarto Lives, Quarto Drives, Quarto Explores, Quarto Gifts, or Quarto Kids.

First published in 2014 by Quarry Books,
an imprint of The Quarto Group,
100 Cummings Center, Suite 265-D,
Beverly, MA 01915, USA.
T (978) 282-9590 F (978) 283-2742
www.QuartoKnows.com

Quarry Books titles are also available at discount for retail, wholesale, promotional, and bulk purchase. For details, contact the Special Sales Manager by email at specialsales@quarto.com or by mail at The Quarto Group, Attn: Special Sales Manager, 401 Second Avenue North, Suite 310, Minneapolis, MN 55401, USA.

Library of Congress Cataloging-in-Publication Data
Berry, Jill K., author.
 Map art lab : 52 exciting art explorations in map making, imagination, and travel /
Jill K. Berry, Linden McNeilly.
 pages cm. -- (Lab series)
 ISBN 978-1-59253-905-5 (paperback)
 1. Maps in art. 2. Map drawing--Technique. 3. Cartography in art. I. McNeilly,
Linden, author. II. Title.
 N8222.M375B47 2014
 526--dc23

 2013038950

ISBN: 978-1-59253-905-5

Digital edition published in 2014
eISBN: 978-1-62788-031-2

Design: Leigh Ring // Ring Art + Design // www.ringartdesign.com
Cover Image: Jill K. Berry
Image on page 80 courtesy of the Australian National Maritime Museum.
Images on pages 106 and 107 courtesy of Peter Clark and The Rebecca Hossack Gallery.
Image on page 134 courtesy of the Corita Art Center, Immaculate Heart Community.

Printed in USA

MAP ART LAB

52 EXCITING ART EXPLORATIONS IN MAPMAKING, IMAGINATION, AND TRAVEL

Jill K. Berry & Linden McNeilly

QUARRY

CONTENTS

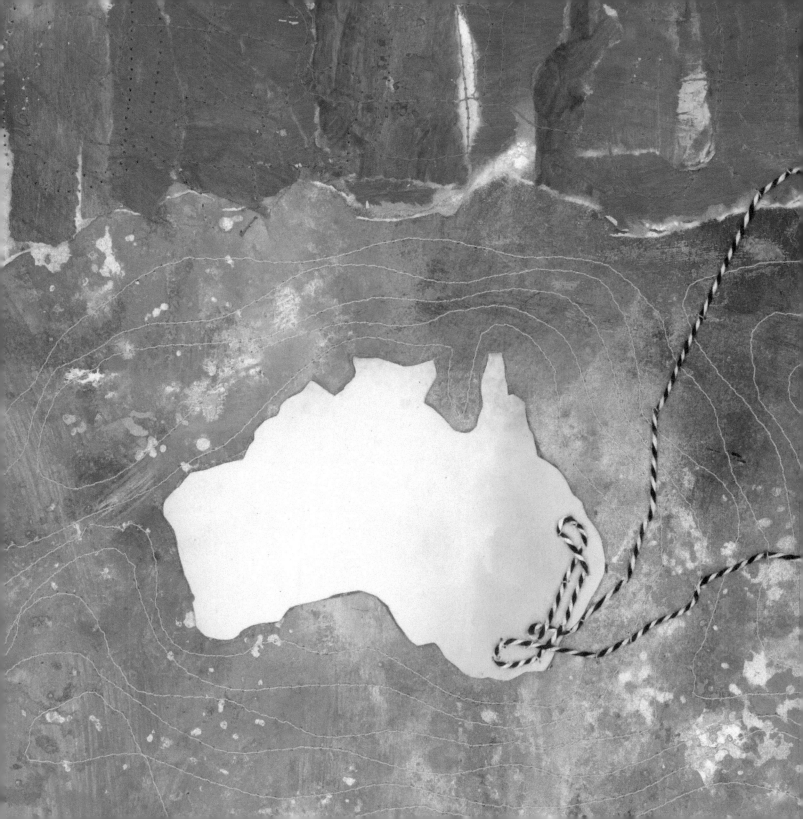

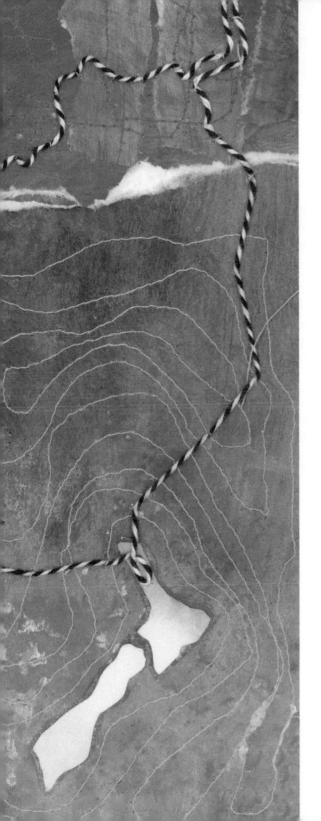

INTRODUCTION

Strange lands, wild creatures, and the promise of adventure have beguiled map lovers for many centuries. Maps are spectacular pictorial evidence of the exploration and curiosity of artists, navigators, explorers, and pirates throughout history. Why not add fun and continue the tradition in new and inventive ways?

Most of us consider maps to be pretty serious and truthful business, more science than art. In school when the teacher pulled out a map, we believed the information on it was pure history and fact. The truth is, many historical maps are fiction posing as fact, and are artful rather than scientific. Mapmakers wanted to tell stories of adventure and discovery, and those stories were just as stories are meant to be: often tall tales that hardly resemble the absolute truth. Mapmakers rarely had the experience they needed to be certain of all the details on their maps, so they listened to others, read books, researched at their local libraries, and then set to making their art. There was no Internet or fact-checking to challenge them. Sometimes they made mistakes on maps by accident. Other times the maps they made were purposefully false: They wanted to lead the competition in the opposite direction, or convince someone of something for selfish gain.

Those of us who want to be called *mapmakers* come from a long line of people who were inventive, creative, skilled—liars, thieves, and pirates. Even now, they leave us to interpret stories filled with wonder and beauty. They left us the tradition of making our own stories by way of maps. Making maps is a joy, both because maps are beautiful to look at and because they lead us through our histories and dreams in a way that no other art form really can.

THIS BOOK IS AN INVITATION

We can't resist making maps. Cave painters tens of thousands of years ago left record of the patterns of stars and the paths of arrows seeking game. Humans in many cultures have continually made maps from ancient times to modern times—it is an age-old craft for the curious.

Even though the earth, the sky, every continent, and every sea on this planet has been mapped, we continue to make maps. Why? Because making maps is a way of understanding. We make maps to sort out the physical world, to see its size, shape, color, and texture. We make personal maps to share our experiences and travels, relationships, and ideas. Our historical maps help us understand the past. Most of all, maps help us find our place in the world.

There is a wealth of books on cartography, geography, and mapmaking, and beautiful books of maps as art, filled with professional renditions of cartographic wonders.

This book is an invitation, a portal, a bridge between those two kinds of books. We want to entice map lovers to become mapmakers, to enjoy the supreme pleasure of making maps as a tool for self-discovery, art-making, storytelling, and recording your dreams and memories.

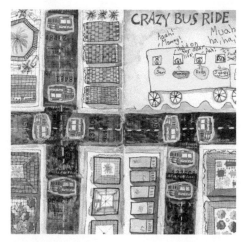

Funny

Quirky

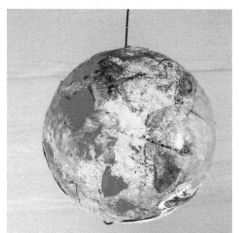

Dimensional

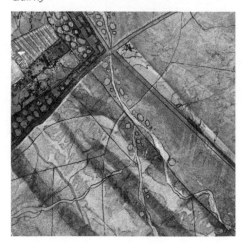

Artful

Maps can take many shapes. They can be concrete or abstract, three-dimensional or absolutely flat.

We hope to show you that mapmaking is also easy, fun, and satisfying. We hope to convert you into an arty cartophile.

WHO SHOULD USE THIS BOOK?

This book is for individuals, teachers, and groups of all ages. If you are a curious explorer who likes to visually record your wanderings, you can be a mapmaker. If you are a storyteller looking for new ways to communicate your stories, you can be a mapmaker. If you are curious about yourself, you might find a huge amount of fun and satisfaction in making maps.

Individuals can use this book in many ways. These projects were designed to present new artistic skills in a fun, easy way while allowing you to express yourself through the lens of a map. You can use these techniques in projects of all kinds: bookmaking, working in journals, schoolwork, or any other project calling for multimedia artwork. You'll learn more about what makes a map and then break all the rules when you make your own. You'll delve into areas you hadn't thought possible to map and come away with an increased understanding for and a deeper connection with what matters.

Teachers can use this book to design lessons that teach skills related to maps, artistic ways to understand maps, and creative ways to organize information from stories, history, and science. Maps can be the perfect palette for self-reflection, allowing you to examine relationships and demonstrate knowledge. Plus, the materials are fun to work with—students of all ages will love them!

Many of the projects are great fun to do as a group: When everyone brings something to the table, wonderful surprises occur. Other projects can be done individually as part of a collective, reflecting both personal visions and the spirit of the group. There is no end to exploring ways to use mapmaking to increase connections and build bridges between people.

Every territory you decide to explore through mapmaking will enrich your life in ways that may surprise you. Mapping your relationship, your vacation, the book you are reading, daily life, and dreams and longings will heighten your experiences. And incorporating maps into your art or art projects is colorful and fun.

Let's explore the world of maps!

MATERIALS

MAPS CAN BE MADE OF ANYTHING

You can make a map out of almost everything and practically nothing. In this book you'll find maps and map elements made from craft materials, natural materials, and upcycled materials.

The supplies in this book are suggestions only. Many of these maps use the basics in anyone's arty tool chest: pens, paper, things to color with. Others involve more specialized materials, but everything can be adapted

to what you have on hand or can easily get. Don't have colored wire? Try pipe cleaners or yarn. No paint brayer? Use a foam paintbrush from the hardware store or a flat sponge from your cupboard. Craft dough—made from flour and salt—can be switched out for polymer clay. The sky is the limit, and because the point is exploration and fun, there's no such thing as doing it wrong.

SUGGESTED MATERIALS

Pencils
Drawing: 2B and 4B
Colored pencils
Watercolor pencils
Stabilo Aquarellable black pencil

Pens
Waterproof pen, such as a Micron

Other Mark Making
Pastels
Crayons: watercolor and wax

Paints, Dyes, and Ink
Black ink, such as sumi ink
Walnut ink
Watercolor paints: transparent, iridescent, and opaque
Acrylic paint
Dye inkpads

Paper
Paper: sketch, watercolor, text-weight, and
 heavy graph paper
Paper ephemera, such as brochures, tickets, book
 pages, photos, or even junk mail
Clip art (one great, free source is thegraphicsfairy.com)
Maps to trace, copy, or cut up

Adhesives
Washi or other decorative tape
Craft glue

Other Craft Items
Brads, buttons, and grommets
Polymer clay
Art tissue: solid and patterned
Semitransparent sheets of plastic, vellum,
 acetate, or similar medium
Stickers
Broken ceramic or tiles
Shells, beads, or beach glass
Styrofoam sphere
Craft wire
Ribbons
Fabric: felt, wool, and cotton
Jewelry findings
Tyvek or nontearable synthetic cloth
Construction wire

Tools
Things to cut with: scissors, craft knives, and
 wire cutters
Ruler and measuring tape
Compass or protractor
Rubber stamps, stencils, and stencil brushes
Lollipop sticks
Paintbrushes for acrylic and watercolor
Foam roller and sponges
Sewing needles and thread of different weights
Needle-nose pliers

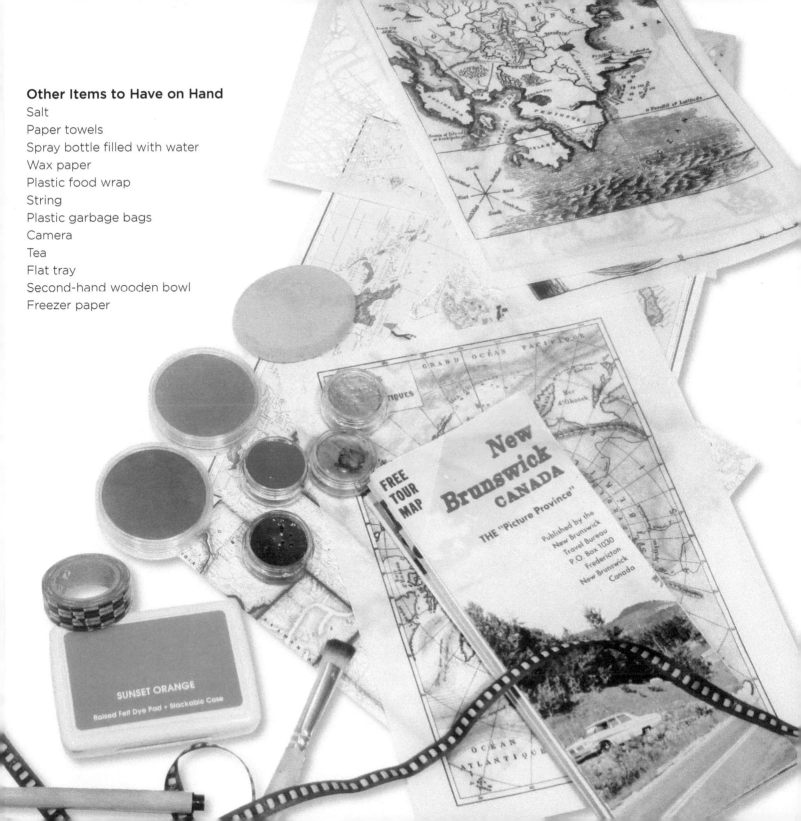

Other Items to Have on Hand
Salt
Paper towels
Spray bottle filled with water
Wax paper
Plastic food wrap
String
Plastic garbage bags
Camera
Tea
Flat tray
Second-hand wooden bowl
Freezer paper

UNIT № 01

MAP BASICS

Welcome to the world of hand-crafted maps! In this chapter you will learn about and play with the tools of the trade, based on age-old tradition combined with new methods.

Historical mapmakers did more than record land and sea. They used maps to fool, educate, steer, advertise, remember, romanticize, influence, and warn. To add great appeal to their maps (and therefore their agendas), they added elaborate cartouches (decorative frames), neatlines (borders), legends, and flora and fauna. Maps are often exquisite to look at because of these visual elements.

Here are some easy ways to make cartographic components to decorate and illustrate your maps, without time-traveling to Queen Isabella's Cartography Court for training. You can use stamps, clip art, and upcycled ephemera—all the things our predecessors would have used had they had access to our supplies.

Let's journey to the land of artful cartography!

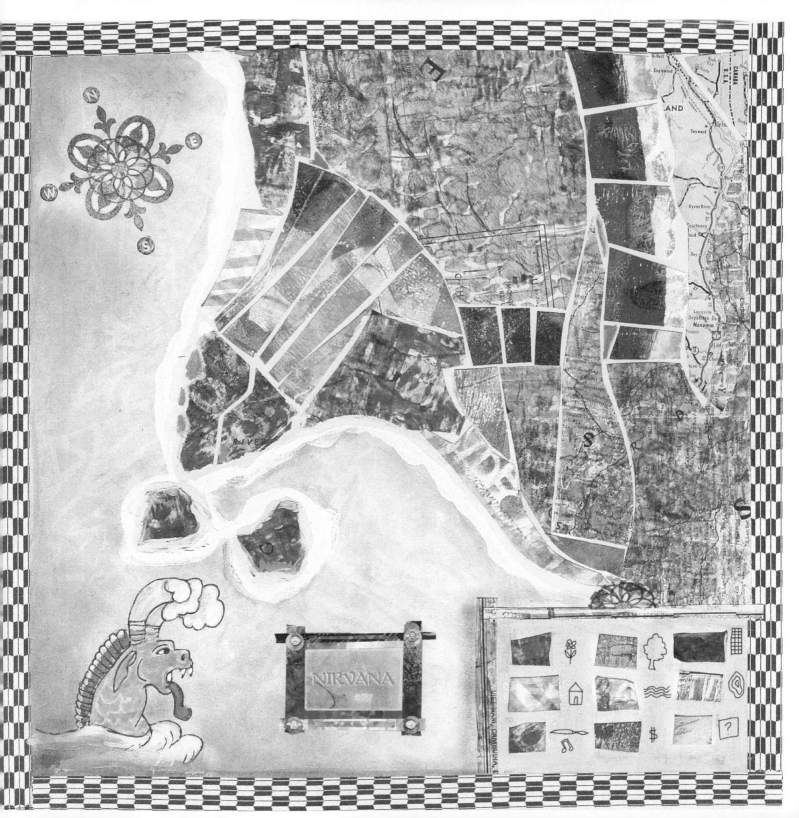

MATERIALS

→ Paper

→ Pencil

The orientation of a map is the direction the map points compared to the compass or reality. This gives you the relative location of the mapped area and helps you locate where you are.

It is now common for a map to be oriented to the north, but it was not always that way. Before "magnetic north" was discovered (between the years 1200 and 1500, depending on who you talk to) maps were oriented in nearly every direction. Religious maps were oriented toward the east, where paradise was believed to be and where the sun rose. Chinese maps were oriented towards the south because this is where the sun reaches its highest point in the sky during the summer solstice. This ancient cosmological view is what translates to feng shui in modern times. Polar maps are necessarily oriented toward the center of the map, with all cardinal directions equidistant from the pole.

In other words, the orientation is up to the maker of the map, and the tradition is to map oneself at the top or center of the map.

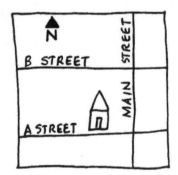
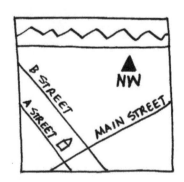
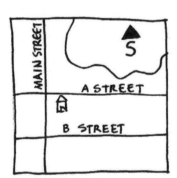
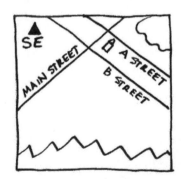

INSTRUCTIONS

Make sketches of your map in different orientations to see which one might show all that you want to include on your map. If there is a lake you like to fish to the south of your house, you might want to have a southern orientation. If you hike in the mountains to the west, turn the map a little and have it face northwest to show the mountains.

ORIENTATION
These maps are oriented every which way, depending on what is being mapped and how the cartographer wanted to draw it. North orientation is common now, but wasn't always.

Historically, maps were oriented in many directions

LAB № 02 COMPASS ROSE

❖ MATERIALS ❖

→ Paper

→ Compass or protractor

→ Ruler

→ Ink pen

→ Watercolor pencils

→ Clip art (optional)

→ Ink stamps (optional)

→ Stencils (optional)

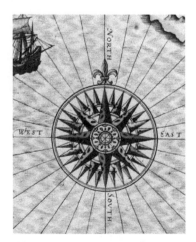

This compass rose was from a vintage map of Ireland.

The compass rose is both beautiful and functional, indicating the four cardinal directions: north, south, east, and west, and sometimes their intermediaries. It is based on the degrees of a circle. The compass rose is essential to a map holder to orient the land on the map. Original roses on maps were called "wind roses," and they indicated the thirty-two directions of the prevailing winds. When magnetic north was discovered, the rose became a compass rose and began to consistently point to the north on maps.

❖ HISTORY TIDBIT ❖

Traditionally, red, blue, black, and green were common colors used in the compass rose (left). Prior to the advent of efficient lighting, these colors were the easiest to distinguish by the dim light of oil lamps and candles.

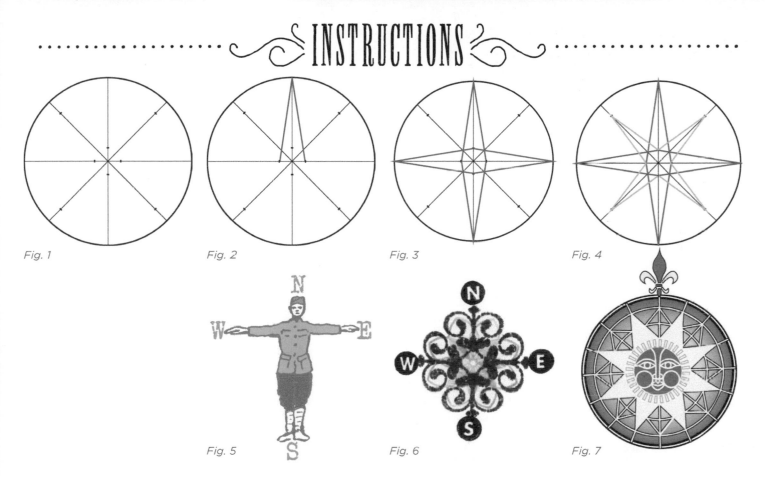

Fig. 1 Fig. 2 Fig. 3 Fig. 4

Fig. 5 Fig. 6 Fig. 7

1. Draw a circle with a compass or protractor. Divide the circle with perpendicular lines through the center. Divide it again on the diagonal until you have eight equal pieces.

2. A short distance out from the center, make tick marks evenly on the horizontal and vertical lines. Draw additional tick marks a short distance from the edge of the circle on the diagonal lines. (Fig. 1)

3. Create points by connecting the tick marks at the circle edge to those near the center. (Fig. 2) Continue this on all four sides. (Fig. 3)

4. Make shorter lines for the intercardinal directions by starting those points a short distance in from the circle. (Fig. 4)

5. With the watercolor pencils, color each directional point with two tones. Add watercolor sprinkled with salt for texture. (See the finished art, opposite.)

6. Add circles, faces, or other objects you fancy at the center. A compass rose can be made in many other ways. Clip art figures make good foundations for the compass rose. Just add the four directions. (Fig. 5)

Symmetrical rubber stamps make excellent compass roses. Use letter stamps for the cardinal directions. (Fig. 6)

This last compass rose was made with a stencil. (Fig. 7)

LAB №03 LEGENDS

❧ MATERIALS ❧

→ Clip art or other images related to your map

→ Sketch paper

→ Pencil

→ Colored pens or pencils

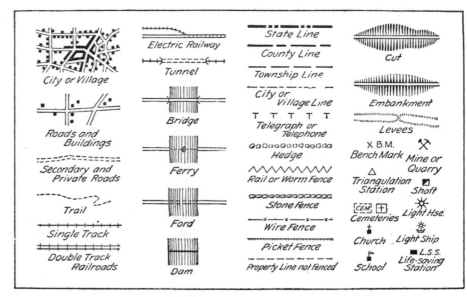

Simple drawings work well for legends.

Map legends are also known as keys and contain symbols used to depict items on the map. These can include landforms, human made objects like buildings, or resources like minerals. A legend explains the pictorial language of the map, known as its symbology. Icons can be representational or symbolic. Legends can be contained within a cartouche (refer to page 22) or placed anywhere on the map.

Map of Yellowstone

This map shows the surfaces found in a backyard.

1. Using clip art or sketches, develop icons to represent the items on your map. You can be literal or symbolic, using shapes, icons, or colors. Your choices will influence the tone of the map.

2. Try making a sketched map, and pick a legend—pictorial, colorful, or symbolic—that best represents the attitude of your map. The *Pets in My Neighborhood* example below is playful and fun.

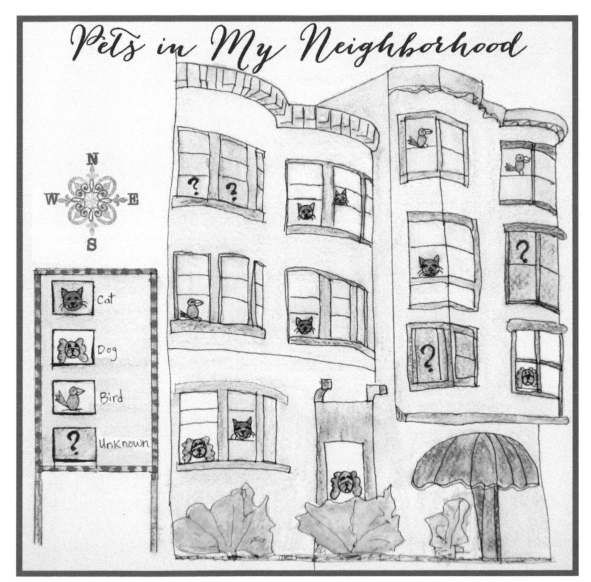

Pets in my neighborhood.

CREATING SEA MONSTERS

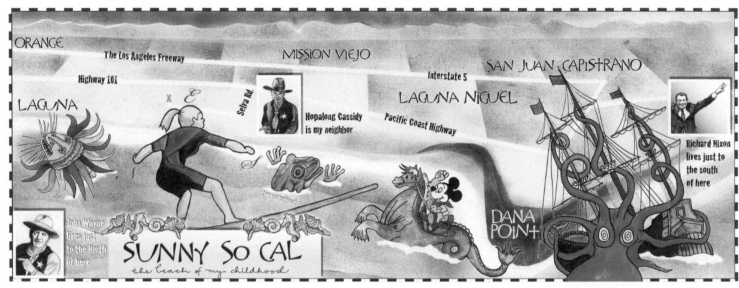

It was fun to add monsters off the shore of the beach of my childhood.

MATERIALS

→ Prints from clip art books or images from StrangeScience.com

→ Soft pencil

→ Watercolor paper

→ Red pencil

→ Waterproof pen, such as a Micron

→ Watercolors

→ Watercolor brushes

Sea monsters appeared on maps for hundreds of years, and not even experts know exactly why. Were those sailors so sea-weary they imagined whales to have beards or manatees to appear as glamorous mermaids? Whatever the reason, fantastical sea creatures appeared in huge numbers on maps from the tenth through the seventeenth centuries. They come winged, fanged, flippered, snakelike, and humanoid. They can resemble snakes, dogs, cats, clerics, devils, women, and horses. You can add sea monsters to any map by using this simple method of transferring and translating the great monster masters.

"So Geographers, in Afric-maps,
With savage-pictures fill their gaps;
And o'er unhabitable downs
Place elephants for want of towns."

—Jonathan Swift

··· ⚞ INSTRUCTIONS ⚟ ···

Fig. 1

Fig. 2

Fig. 3

Fig. 4

1. Flip over the print of the monster you want to draw.

2. Using your soft pencil, color the back of the drawing. (Fig. 1)

3. Turn the drawing over and place it on top of the watercolor paper, in the position you want.

4. Trace the outlines with the red pencil. Use red so you can see what you have traced. Do not press too hard; you will indent the watercolor paper. (Fig. 2)

5. Lightly sketch in the drawing if it is faint.

6. Outline the drawing with waterproof pen. (Fig. 3)

7. Paint the creatures with watercolors. (Fig. 4)

❧ MAP LORE ❧

Conrad Gesner did drawings for his woodcuts both from real creatures and from descriptions of sightings by sailors. Olaus Magnus, who described a horned whale looking like "a tree rooted up by the roots," originally reported this "bearded whale" in 1558. I thought he was just perfect for a "hippy monster" on my map of southern California in the 1970s. (I also used him in "Custom Constellations" on page 57).

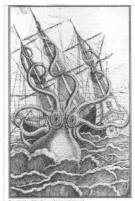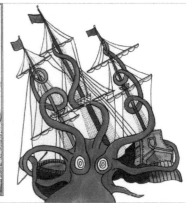

Giant squid attacking The Pilgrim, *Richard Henry Dana's ship, for whom the area was named.*

LAB № 05 CREATIVE CARTOUCHES

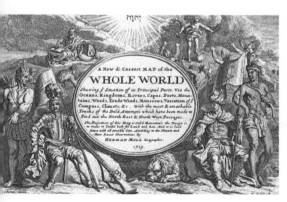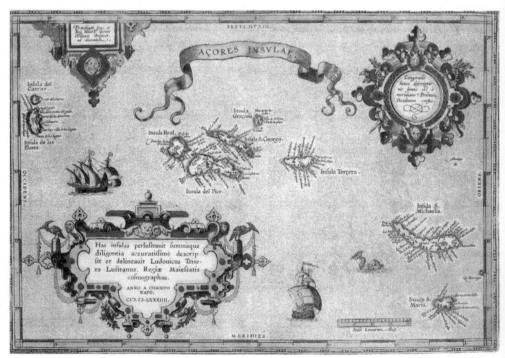# MATERIALS

→ Ruler

→ Paper

→ Pencil

→ Rubber stamps or stencils (optional)

→ Fine-point markers

→ Washi or other decorative tape

→ Craft knife

→ Brads, buttons, and other decorative elements

Cartouches are decorative elements that frame map titles and other information about the map. They can add an artistic narrative to the maps they describe. Cartouches have been around for many centuries, but they became popular in the beginning of the sixteenth century. Below are two examples of cartouches that act as social commentary as well as adding a fantastic visual element to the map.

Cartouches can be made using many techniques, including drawings, rubber stamping, stenciling, and decorative tape.

Azores, 1584. The cartouches of this map of the Azores take over the map of the islands.

New & Correct Map of the Whole World, Herman Moll, 1719.

To make a drawn, stamped, or stenciled cartouche:

1. Using your ruler, draw a rectangle the size of your desired cartouche in pencil.

2. Add thematic graphics around the edges by sketching or using rubber stamps or stencils that match the tone of your map.

3. Color in with fine-point markers, if desired.

4. Insert the title and other map information in a style matching your theme.

To make a cartouche using washi or decorative tape:

1. Using your ruler, draw a rectangle in pencil. It's good to start with a larger shape than the completed cartouche will be.

2. Lay down washi tape. Trim it to a narrow width, use it full size, or incorporate both. As you add tape, work inward.

3. Trim the corners to a point using the craft knife.

4. Add decorative elements, such as brads and buttons.

5. Insert the title and other map information in a style matching your theme.

LAB № 06 NEATLINES

⚜ MATERIALS ⚜

→ White tape

→ Black paper

→ Cutting tool

→ Steel ruler

A neatline is a border commonly drawn around the extent of a map to enclose it and all its decorative pieces and parts, keeping all the information pertaining to that map in one "neat" box. Neatlines surround the whole picture the mapmaker wants to show. They also indicate whether the map is complete. If there are neatlines on one side of the map and not the others, you know you do not have the whole map; part of it is missing.

Visually speaking, neatlines are a great addition to a map because they can be so varied and interesting—often seen are dashed lines, solid lines, or a combination, in bold black and white or in various colors.

Draw lines in any color you like.

INSTRUCTIONS

1. Place the white tape across the black paper, leaving spaces between strips of tape the same width as the tape to make even lines.

2. Slice the paper into strips and paste the strips on your map.

Use ribbons and fabric trims.

Use decorative tapes.

SCALE YOUR BEDROOM

❋ MATERIALS ❋

→ Measuring tape

→ Paper

→ Colored pencil

Because an accurate map represents land far too large to draw literally, each map has a scale. Scale is the ratio of a distance on the map to the corresponding distance it represents.

A graphic scale is a line sectioned and labeled with the corresponding ground measurements it represents. A graphic scale often includes both metric and U.S. common units. As long as the size of the graphic scale changes with the map, it will be accurate.

Map sizes are often referred to as large scale or small scale. A large-scale map is one that shows greater detail—and therefore less area—than a small-scale map. A world map that fits on a letter-size page is very small scale.

INSTRUCTIONS

1. Measure the paper. Using the same units, measure your room, and determine the scale by dividing the paper size by the room size. For example, if your paper is 8 inches (20.3 cm) across, and your room is 72 inches (183 cm) across, every drawn inch/centimeter equals about 9 actual inches/centimeters, so the scale is roughly 1:9.

2. Now, sketch in the other areas in the room, taking accurate measurements as you go, and reducing them on the page by the scale.

3. Color as desired.

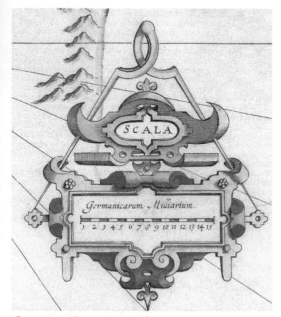

Seventeenth-century scale

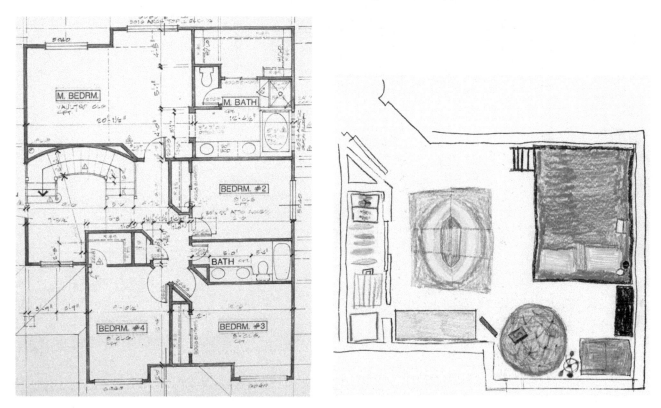

Sydney Berry drew her bedroom with a larger scale than the corresponding blueprint for the house.

◆ HISTORY TIDBIT ◆

This 1798 map of Veracruz, Mexico, has two scales on the same map. Framed in the stair-step border to the left is a small-scale map of the region with the port printed in pink below the cartouche. To the right is the pink port plan in large scale.

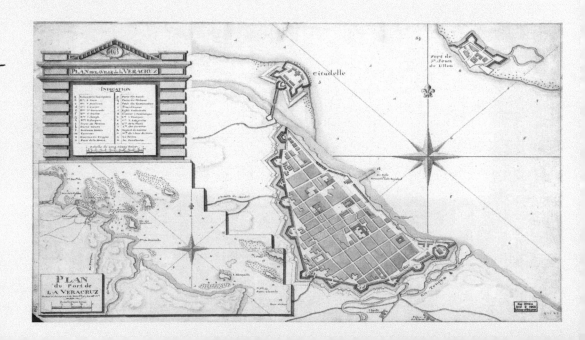

TOPO YOUR NOSE

⁕ MATERIALS ⁕

→ Polymer clay

→ Fine-point permanent pen

→ Craft knife

→ Craft oven or dedicated toaster oven

→ Acrylic ruler

Topographical maps show the contour of land—mountains, gullies, and everything in between—with lines indicating elevation.

Topographical lines can look confusing if you don't know how to read them. A mountain can resemble the surface of a pool of water you've just thrown a rock into. That's not very helpful if you're making your way through a thick forest, depending only on a topographical map to avoid the deadly swamp. Here's a fun way to explore what topography means, up close and personally.

⁕ HISTORY TIDBIT ⁕

The concept of contour lines to show different elevations on a map was developed by the French engineer J. L. Dupain-Triel in 1791 but was not widely used until the mid-1800s.

⁕ TAKE IT FURTHER ⁕

Topo maps can become elevation maps by adding color to represent the elevation above sea level. Here, the topo nose rises proudly above the sea!

Side-view elevation map

Elevation Legend
Green = 0–¼" (6.5 mm) from base
Yellow = ¼–½" (6.5–13 mm)
Red = ½–¾" (13–19.5 mm)
Blue = ¾–1" (19.5–26 mm)
Pink = 1" (26 mm) to top of nose

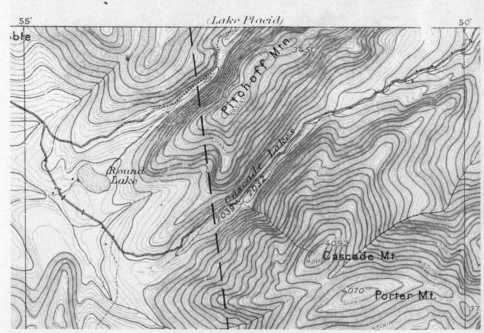

TOPOGRAPHIC SHEET

Sample from USGS topographical map of Adirondacks, New York, 1892

1. Roll polymer clay into a ball, then press it into an oval ¼″ (6.5 mm) thick. Shape it over your nose, pressing it into the contours of the bridge and around the nostrils. Pull it gently off your nose and press more clay into it while maintaining the shape. Trim away the excess using a craft knife and reshape the clay to resemble your nose.

2. Bake your sculpture in a craft oven at the manufacturer's specified temperature for 7 minutes.

3. Let it cool just enough to handle. Using an acrylic ruler and permanent pen, mark off horizontal ticks every ¼″ (6.5 mm), starting from the bottom up on all three sides of the nose. Connect the horizontal tick marks into lines all the way around your clay nose. (Fig. 1, 2)

4. Make vertical lines from the top down to the bottom edge in two places so you can line them up later.

5. Keeping a craft knife level with the table, slice each horizontal level off carefully. (Fig. 3)

6. Place the pieces back in the oven and continue to bake for 13 more minutes.

7. When the clay is cool and hard, gently smooth the rough edges. Starting with the largest piece, trace the outside onto paper. Line up the next size piece with its tick marks and trace it. (Fig. 4)

8. Continue lining up and tracing the pieces. Label the elevations. (Fig. 5)

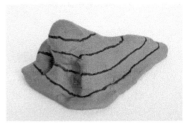

Fig. 1

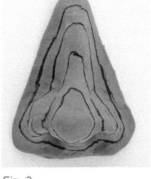

Fig. 2

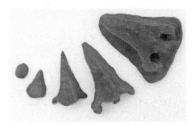

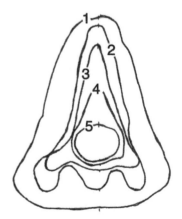

Fig. 3

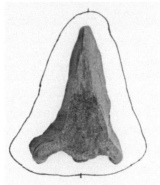

Fig. 4

Fig. 5: Topo legend

1 = 0–¼″ from base (6.5 mm)

2 = ¼–½″ (6.5-13 mm)

3 = ½–¾″ (13-19.5 mm)

4 = ¾–1″ (19.5-26 mm)

5 = 1″ (26 mm) to top of nose

MAP MAGIC

Map elements can be found everywhere: in seashells, crumpled wax paper, the folds of plastic wrap, and ink running down the page. Strings remind us of the longitude and latitude lines and stencils suggest houses and the roads between them. Layers of semitransparent material create a dreamy idea of the past.

In this unit you will explore techniques for creating map elements using ordinary materials, such as tissue paper, string, wax paper, and plastic wrap. The maps may be designed to use alone or in any combination for map projects, journal pages, or collages. These are the building blocks that make art maps magical.

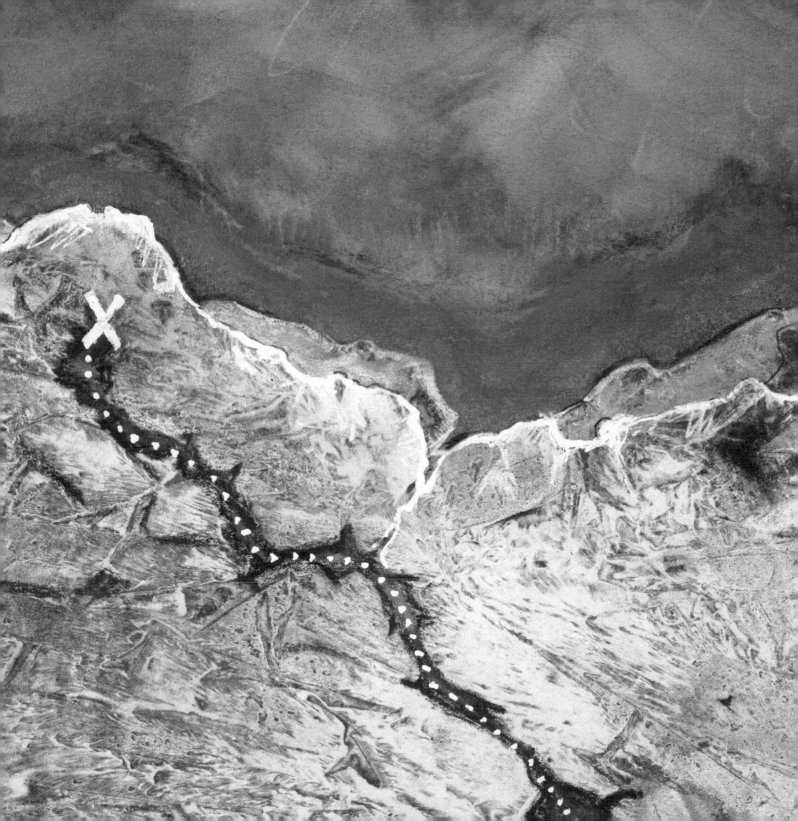

GEO PAPER 1: FLYING OVER KANSAS

❖ MATERIALS ❖

→ Spray bottle with water

→ Printmaking paper that can take moisture, such as Arches Text Wove

→ Small watercolor brush

→ Dark, black, smooth ink, such as sumi ink

→ Things that are round, to trace for circles

→ Water-soluble black pencil, such as Stabilo Aquarellable

→ Kosher salt

→ Paper towels

→ Transparent watercolors (not opaque or gouache)

→ Anything you like to add texture

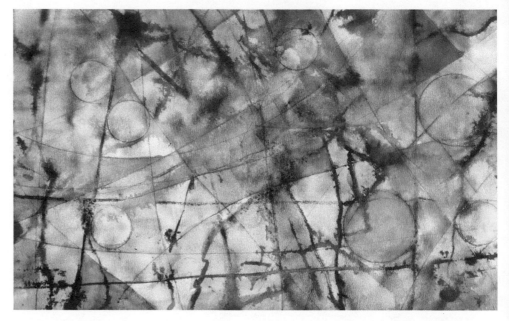

Seeing the land from the air is one of the most exciting gifts of the modern age. Every time we fly, we are reminded of the journeys made across vast lands full of opportunity.

This exercise explores the shapes, colors, and contours of farmland with its borders and waterways, and creates a paper that can be used for many kinds of projects. Go wild if you want to. It's your world and you call the shots.

Did you know that the circles in fields you see from an airplane are created by pivotal irrigation machines? These machines were invented in 1947 by Frank Zybach, a farmer from Nebraska. Just twenty-five years later there were as many as 19,000 of these machines in Nebraska alone. This way of watering revolutionized farming in unpredictable rainfall areas and is now used all over the world. It makes for a stunning pattern from the air!

1. Using the spray bottle, spritz—but don't saturate—the paper. Paint a line from the top edge with a small brush dipped in ink. Where the ink hits the wetter part, the line will feather. Make a line perpendicular to the first line. Continue painting lots of lines going in both directions. These lines can be wiggly, just make sure they go from edge to edge, right off the paper. Next, create cool crop circles by tracing a round object with the Stabilo pencil. (Fig. 1)

2. Drop the salt onto the really wet areas to absorb the water and add texture. (Fig. 2)

3. Continue to add circles with the Stabilo pencil and use the small brush to add some irregular lines for waterways. Keep adding circles and lines until you are happy with your creation. (Fig. 3)

4. Lift one edge to let the wet areas run across the paper.

5. Let it dry completely before moving on. When the paper is entirely dry, wipe off the salt with a dry paper towel. (Fig. 4)

6. Get out the watercolors. (We especially love using Twinkling H2Os.) Paint in the pastureland, waterways, and farms. Keep adding layers until you like your new land. You can add salt or other texture to the watercolor layers, too. (Fig. 5)

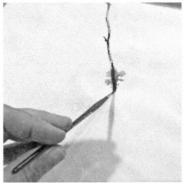
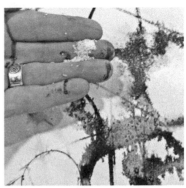

Fig. 1

Fig. 2

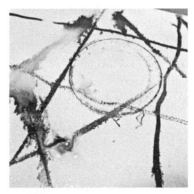

Fig. 3

Fig. 4

Fig. 5

❧ TAKE IT FURTHER ❧

We made a small journal and book in a box. Eventually we will write a message on it, such as "Where have you been all my life?" or maybe "I have been looking everywhere for you," and then give it to someone.

GEO PAPER 2:
DRIPPING INK STREETS

• MATERIALS •

→ Printmaker paper that can take moisture, such as Arches Text Wove

→ Eyedropper

→ Walnut ink or another ink of your choice

→ Transparent watercolors (not opaque or gouache)

→ Watercolor brush

→ Black marker and colored pencils (optional)

This is a fun and versatile technique to do with a group or alone. By using flowing ink and rotating your paper, you will make a simple map that can be colored in many ways, bound into journals, or made into wall art.

• TAKE IT FURTHER •

This paper can be bound into a journal, as seen here. In one of my workshops, student Kelly Floyd added textures and colors of Taos, New Mexico, and though the map is not an accurate rendition of the street plan, it is a map of her experience that very much represents her time there.

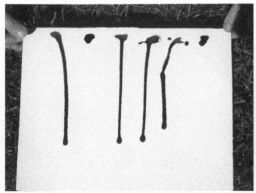

Fig. 1

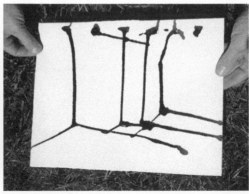

Fig. 2

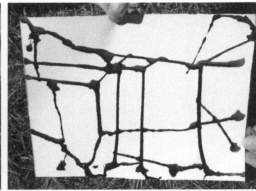

Fig. 3

1. Holding a piece of paper with one hand, use an eyedropper to drip drops of wet ink onto the top edge of the paper, a few inches apart. (Fig. 1)

2 Lift the paper and let the ink run down the page. Before it runs off the bottom edge, rotate the paper. The ink drop will travel in a fairly straight line. Add more drops as you go and keep rotating. (Fig. 2, 3)

3. If you want to let the ink drip off the page, place a colored sheet of paper on the surface below to catch the extra ink. This is the page that was on the table underneath my original page. I rotated it around, too, and let the ink flow where it wanted to. Then I added fine black marker and colored pencil to make my fantasy hill town map. (Fig. 4)

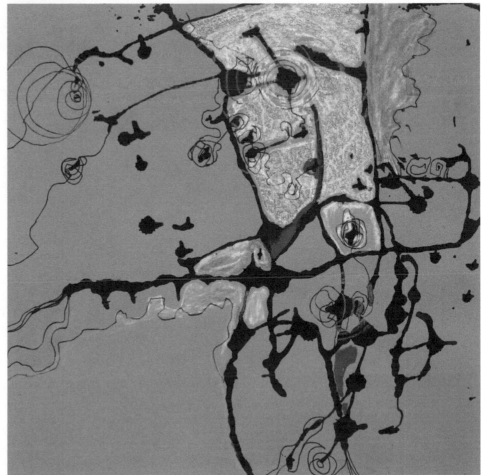

Fig. 4

❖ MATERIALS ❖

→ Paper

→ Water-based paint (acrylic or watercolor works best)

→ Paintbrushes

→ Plastic wrap

→ Wax paper

→ Ruler

→ Waterproof pen, such as a Micron

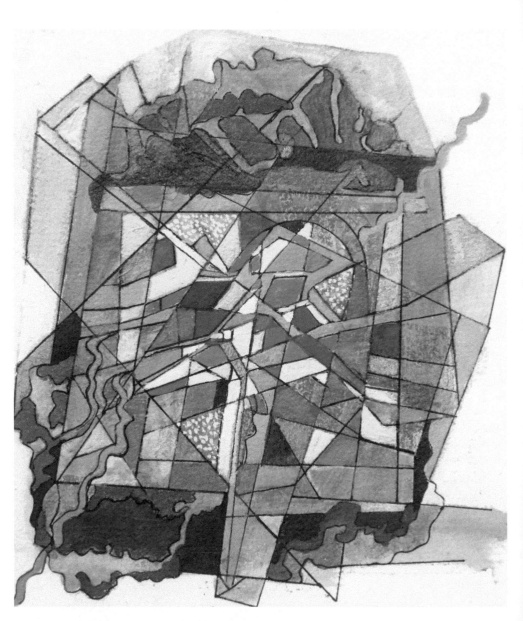

This is a very simple and satisfying technique to use on paper or in journals to create abstract maps that can be left alone or embellished to create fantasy cities and spaces.

INSTRUCTIONS

Fig. 1

Fig. 2

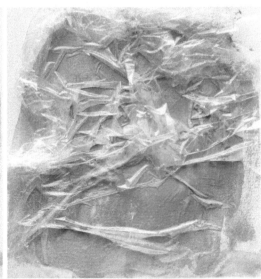

Fig. 3

1. Paint loosely onto the paper, using few colors and not mixing them very much. (Fig. 1)

2. With a wet brush, smudge the colors together a little bit but leave some of each pure. (Fig. 2)

3. Crumple up the plastic wrap (Fig. 3) or wax paper before laying it on top of the wet paint. (Fig. 4)

4. Let the paint dry completely before peeling off the plastic wrap or wax paper. (Fig. 5)

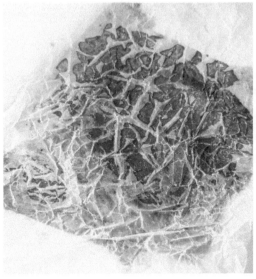

Fig. 4

Fig. 5

5. Using the lines created by the plastic wrap or wax paper, draw out the "streets" and other sections of the map with a ruler and a waterproof pen. Add colors in the newly created zones on your map.

6. Try this with watercolor in a journal. This one was enhanced after drying with more watercolors. See how an ancient city begins to emerge? (Opposite, far left)

STRING UP LONGS AND LATS

MATERIALS

→ Plastic garbage bag

→ Art tissue in white

→ Acrylic paint

→ Paintbrushes

→ String

→ Spray bottle with water (optional)

HISTORY TIDBIT

The grid on a map that provides a way to specify a precise location on the surface of the earth is made up of vertical lines—or longitude—and horizontal lines—or latitude. The measurements and placement of these lines in an accurate way has challenged mapmakers and was the origin of many stories in map history. Latitude was easier to map because it is based on the movement of the sun, but longitude was a different story because those measurements are based on time. Time was hard to measure on ships being tossed at sea, and longitude was not precise until accurate clocks were invented at the end of the eighteenth century.

In this map, we are going to make our own lines of latitude and longitude and then place a fantasy island or territory on it.

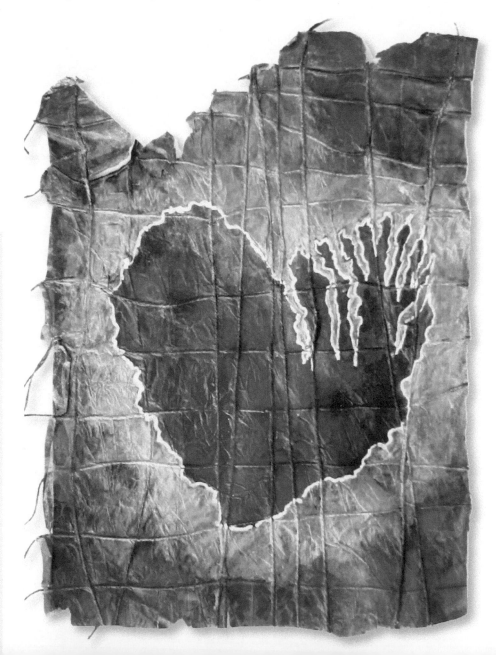

Fig. 1

Fig. 2

Fig. 3

1. Spread the plastic bag over your work surface and place one sheet of white tissue on top of it.

2. Paint the tissue with acrylic paint. This is the background, not the map, so there is no need to get detailed here. (Fig. 1)

3. While the tissue is still wet, lay down the string in a grid in both directions. It is important that the paint is wet, as it will act as an adhesive between the sheets of tissue. Spray the tissue lightly with water if it begins to dry out. (Fig. 2)

4. Place another piece of art tissue on top of the string and paint it. Be gentle so you don't tear the paper around the string. (Fig. 3)

5. When the layers are completely dry, paint your island or territory on your gridded paper.

Bonus: This project is especially luminous when held up to light! (Right)

LAB № 13 STENCIL MAPS

✤ MATERIALS ✤

→ Stencil brushes

→ Dye inks

→ Stencils

→ Heavy paper

→ Waterproof pen, such as a Micron

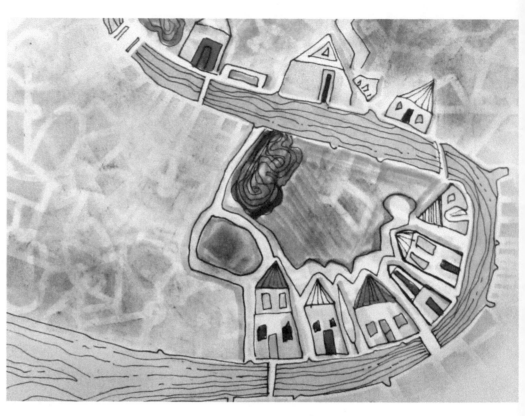

Stencils come in all shapes and sizes—even in the images of maps—and you can use them in layers to make your own maps. I used stencils of random squares, abstract calligraphy, and a map of Venice for these pieces.

Stencils can be used with a variety of coloring agents, including what I used here: dye inkpads and fabric paints. The color you use can be applied with brushes, sponges, or even gelatin plates (if you have access to those), and you can print them on paper, fabric, or just about any other surface.

This technique of using stencils is called *pochoir*, which is the French word for stenciling, but in fact, this form of coloring pictures dates to a thousand years ago in China. *Pochoir* was revived by the French in the Art Deco era, and I would like to revive it again!

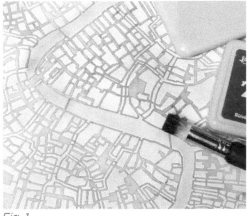

Fig. 1

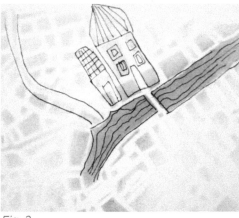

Fig. 2

Fig. 3

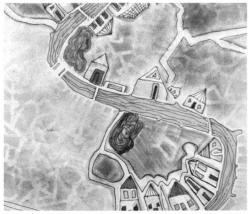

Fig. 4

Fig. 5

Fig. 6

1. Dab the stencil brush onto the dye inkpad, then brush in the part of the stencil you want to transfer. I transferred the river from a stencil of Venice. (See Resources, page 140.) Use various colors to add land and shapes to the paper. (Fig. 1)

2. With a black pen, outline areas that show up. These rectangles make good houses along the river. (Fig. 2)

3. Add layers of other colors using a different stencil to add texture. (Fig. 3)

4. Keep adding layers of stencils with dye inks, and do not worry about overlapping. The layers are fairly translucent. Outline the "neighborhood" you see when finished. (Fig. 4)

The seaside city in Fig. 5 was made using variations on rectangle stencils over and over in many layers. Fig. 6 suggests a city along the Mediterranean.

•MATERIALS•

→ Art paper

→ Art pens

→ Semitransparent sheets of any of the following: acetate, vinyl sheeting, plastic, tracing paper, or vellum

→ Scissors

→ Any colored pens that write on glass, such as permanent opaque pens

→ Colored pencil

→ Acrylic paint

→ Small paintbrush

Maps are often used to show history or progress, and one way to do that is with layers of semitransparent media against paper. These mixed-media maps suggest both visual depth and the passage of time.

The Orange County map (at right) shows the agricultural history on both sides of the top layer, with the present-day maze of streets and highways drawn on the art paper underneath.

The Atlantis map features a paper layer depicting ruins receding behind three layers of semitransparent sheets.

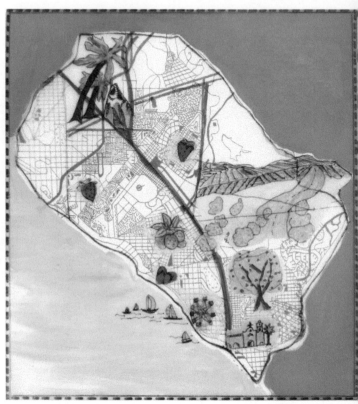

Layer map of Orange County, past and present

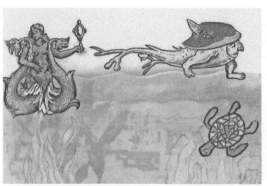

Imagined Atlantis transparent map

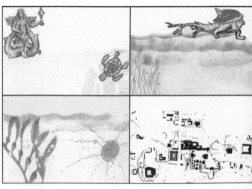

Atlantis map layers

~ INSTRUCTIONS ~

1. Choose the number of layers that best represents the content of your map.

2. Draw your bottommost layer using art paper and pens. This should have high contrast. (Fig. 1)

3. Audition various semitransparent sheets to see which type and how many work for your project. Cut away parts of your top sheets to expose parts of layers underneath, if desired.

4. Using permanent pen, draw on the top. Then flip the sheet and color in your drawn objects on the back. For added richness of color, paint on the reverse side of the plastic sheet over the colored-in areas. Draw on both sides of the plastic, and paint over the back. (Fig. 2)

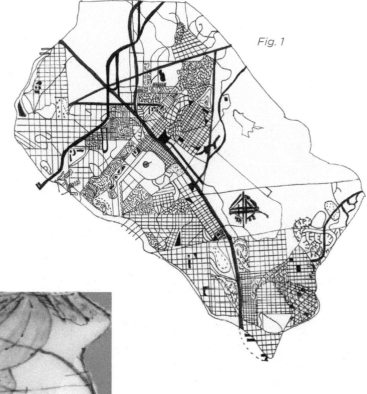

Fig. 1

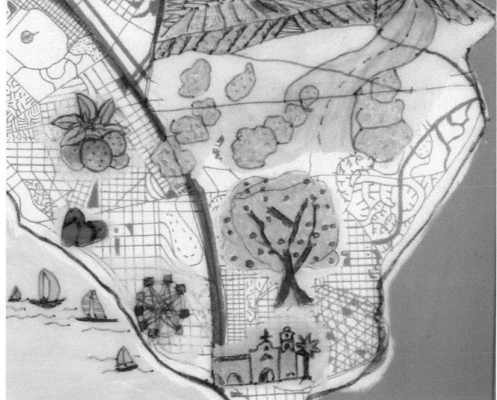

Fig. 2

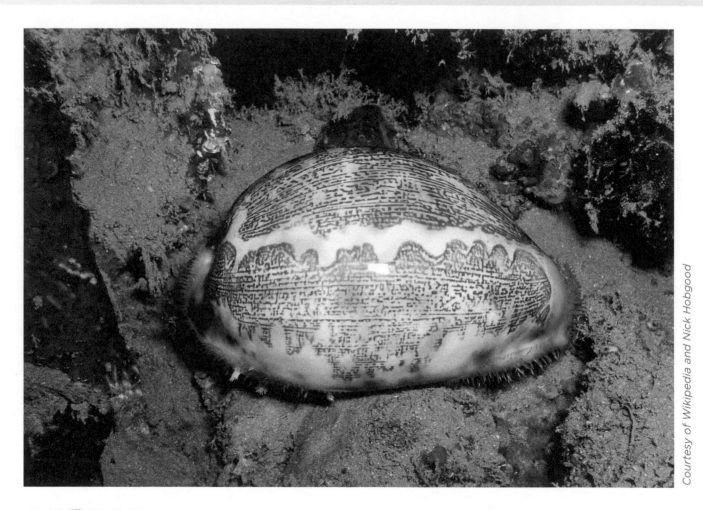

Courtesy of Wikipedia and Nick Hobgood

⊹ MATERIALS ⊹

→ Camera or sketchbook and drawing utensils

Mother Nature turns up some seriously interesting maps. Sometimes they are real journeys of bugs, worms, tides, or water, and sometimes they are patterns made by wind, rain, and time.

This shell is called the map cowry (*Leporicypraea mappa*) because it looks like ancient maps, complete with lines of latitude.

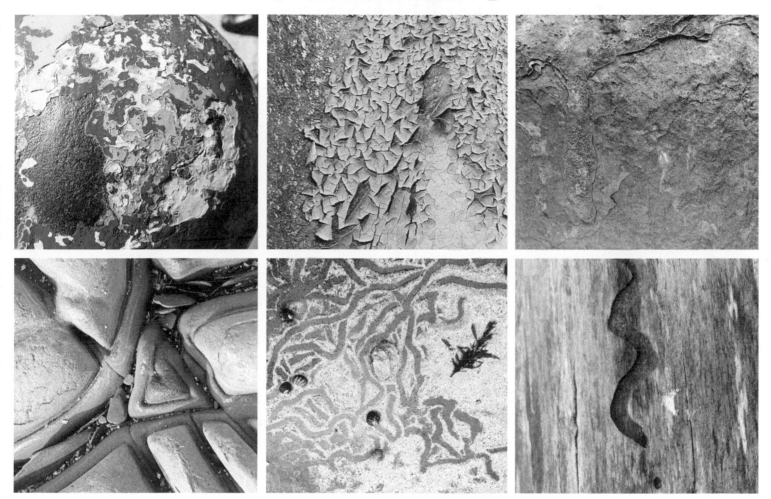

1. Spend some time looking closely at trees, rivers, tide pools, sidewalks, leaves, and the sky.

2. Photograph or sketch anything that looks like a critter has made a journey over it, or any moss that has filled the cracks of the rock map.

3. Assemble your photos into a glorious found map atlas of Mother Nature.

Photos courtesy of Jessica Winder (top, left to right; bottom, left), Chris Betcher (bottom, middle), and David Whelan (bottom right)

One of the most enchanting and frustrating features of a map is how it is folded. There are myriad ways to fold a map, and some stand-out favorites, as shown here. The good news is that neither of these tends to be hard to put back to its original fold; the map just snaps back into place.

MATERIALS

→ 1 square sheet of paper

→ Glue

→ 1 piece cover paper (width of map plus a bit by half the width of final map plus a bit)

Fig. 1

POP-UP MAP INSTRUCTIONS

1. Fold in half vertically, holding the map as it reads, back sides together. Unfold.

2. Fold in half diagonally, right sides together. Unfold. (Fig. 1)

3. Fold in half diagonally the other way, right sides together. Unfold.

4. Bring the sides of 1 together in the center. You should have a triangular paper cup. (Fig. 2)

5. Bring the pointed flaps to the center, one at a time, lining up the upper edges. (Fig. 3)

6. Crease the sides firmly. Do this on all four sides, until you have a house shape. (Fig. 4)

7. Unfold the flaps and reverse them, pushing them inside the center with the creases you just made. (Fig. 5) Add glue only on the very outside edge of the back. Fold the cover paper in half, lengthwise.

8. Set inside the cover, centering the point just outside the fold. Add glue to the front foredge and close the cover. All done! (Fig. 6)

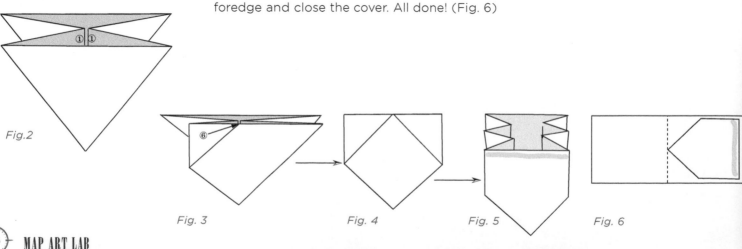

Fig.2

Fig. 3

Fig. 4

Fig. 5

Fig. 6

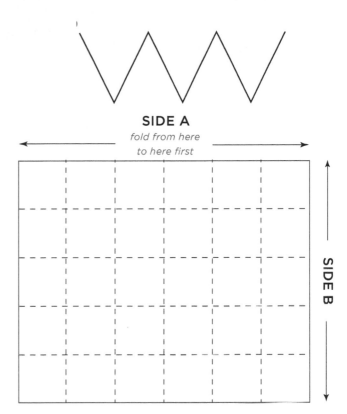

fold from here to here first

SIDE B

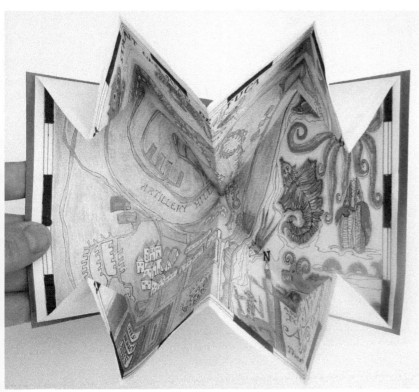

Pop-up map, instructions opposite page

✦ MATERIALS ✦

→ 1 rectangular sheet of paper, 10 x 12 inches (25.4 x 30.5 cm)

→ 1 rectangular piece for folded map (width of map plus a bit by half the width of final map plus a bit)

→ Bone folder

FOLDED MAP INSTRUCTIONS

1. Measure and score fold lines on side A into six equal panels.

2. Measure and score fold lines on side B into five equal accordion panels.

3. Fold side A on the score lines and stack up.

4. Fold side B on the score lines and stack.

5. Pull on two outside corners at the same time to unfold the map.

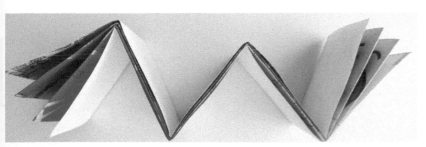

Folded map

UNIT № 03

FLAT MAPS

It goes without saying that traditional maps are flat. In this chapter, however, you'll learn ways to take the elements of flat maps—line, form, and color—in new directions. These maps help you go deeper into your experiences as they call you to play with pattern and color and discover how they both relate to meaning. You'll leave traditional flat maps behind as you revisit trips, find the essential elements of your journeys, and gaze into the sky for inspiration. You even get to take a new look at your dinner and enter the fictional world of your favorite story!

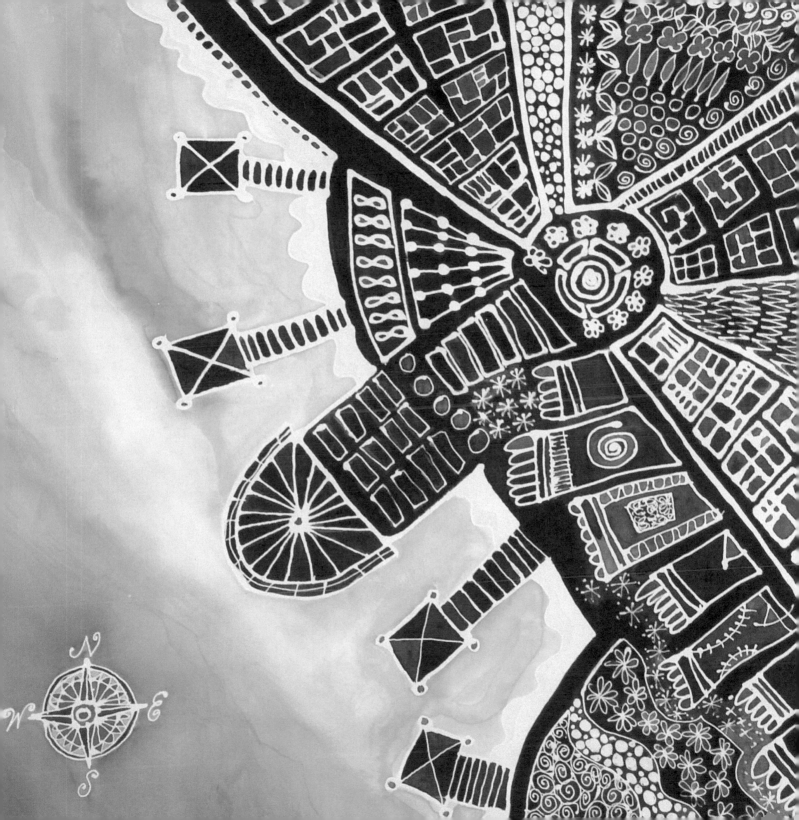

This process of drawing is based on pattern making with pens on paper. There are lots of books on Zentangle® available, and each of them offers patterns for copying and learning.

This map is a hybrid of that process. Some of these patterns are inspired by certified Zentangle® teacher Kass Hall. The others are invented specifically to reflect the landscape of this particular vacation.

⚜ MATERIALS ⚜

→ Watercolor paper

→ Waterproof pens, such as Micron pens, in sizes 03 (0.35 mm) and 05 (0.45 mm)

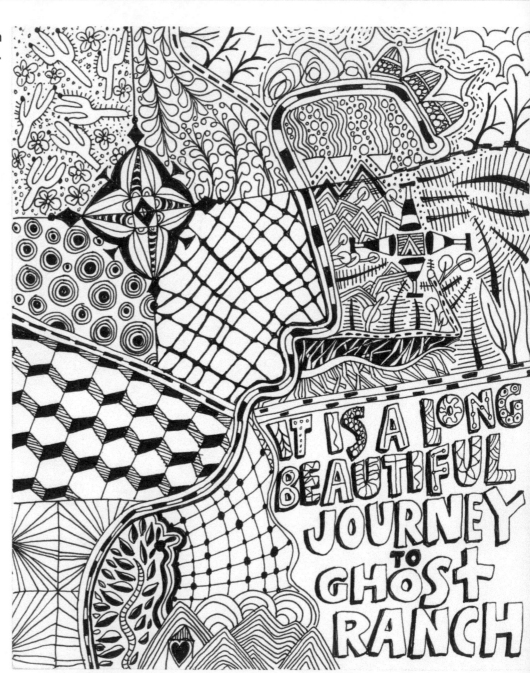

INSTRUCTIONS

1. Sketch a line that will represent your journey. Add a simple pattern compass rose. This one points south, the orientation of this particular trip from Colorado to the desert southwest of there. (Fig. 1)

2. Add some roads. Divide the fields by extending the cardinal points on the compass rose. (Fig. 2)

3. Continue to add patterns and doodles that are inspired by what you saw along the way. Four spinning glasses symbolize the stop at a friend's house. Repetitive pointed patterns symbolize mountains, and black branches along the river symbolize cottonwood trees that grow there.

4. Finally, add a title block and fill the letters with patterns, too. (Opposite)

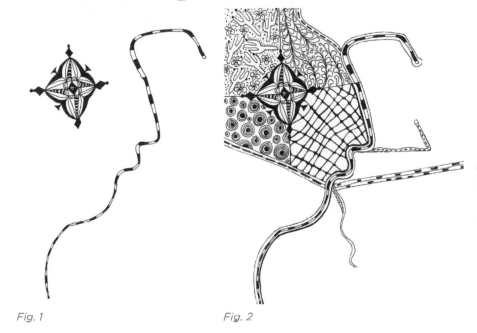

Fig. 1 *Fig. 2*

GUEST MAPPER: BECKAH KRAHULA

Beckah Krahula is a certified Zentangle® teacher. She created this tangled map of Maui to record the fabulous two weeks her family spent there recently. She began by creating a string in the shape of the island using a pencil, and then she divided the island into the regions of Maui. Tangled tiles are traditionally done in an achromatic color scale, but this Zentangle®-inspired art piece had to be in island colors so she used Faber-Castell Pitt Pens. All the tangle patterns represent highlights of the trip: The clouds are from the storm they watched out over the ocean for three days, the hula dancer was from Midnight Mass, purple leis are from the airport; Beckah also included other symbols from the culture of the Hawaiian Islands.

The Zentangle® Method was created by Rick Roberts and Maria Thomas and is copyrighted. Zentangle® is a registered trademark of Zentangle®, Inc. Learn more at zentangle.com.

→ MATERIALS →

→ Pencil

→ Paper or journal page

→ Waterproof pen, such as a Micron

→ Watercolors or markers

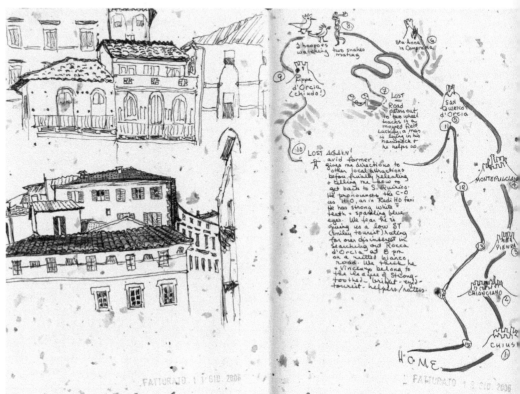

Whether it is a long, flat trip through Kansas or a scene from a plane over France, trips we take become part of our stories and lives. Putting pen to paper to make a map of our trips in journals or on napkins distills our stories to the simplest form.

This exercise is about reducing a trip down to one line, even if it wasn't that simple in reality.

Gwen Diehn, an avid journaler and author, makes maps in her journals that she considers working maps. She says she makes them to help her find her way around places, and to understand the location of where she was while journaling. (Above and left)

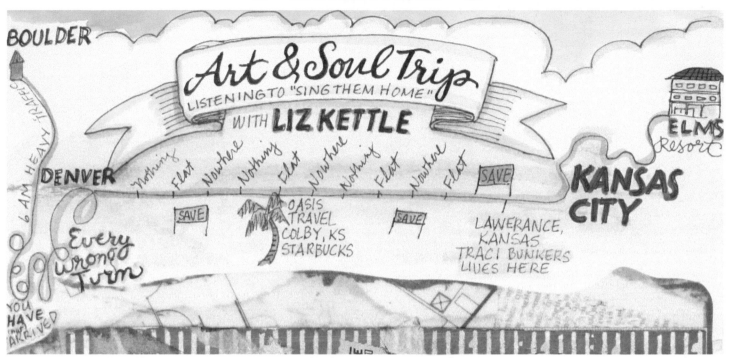

Fig. 1

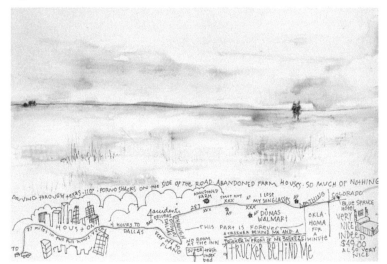

Fig. 2

1. Place your pencil on a journal page or piece of paper.

2. Without thinking too much, draw a line of your trip from one end of the page to the other, moving your hand according to how it felt to take that trip, not necessarily how it reads on the map. For example, my trip through Kansas felt flat and straight for most of the way, with a complex beginning and ending to the trip, so those areas have more detail. Boulder to Kansas City is entirely uneventful, apart from a friend's company and a great audio book. Still, it makes a fun map! (Fig. 1)

3. Using a waterproof pen, make notes of events, sightings, stops, observations, and weather. Add details and color with watercolors or markers. This trip from Texas to Colorado was long and hot, passing many, many abandoned farms on the prairie land on both sides of the highway. (Fig. 2)

LAB № 18 STORY MAPS

→ Story to reference

→ Art paper

→ Pencil

→ Waterproof pen, such as a Micron, in size 08 (0.50 mm)

→ Acrylic paint

→ 2 paintbrushes, one for fine detail and one for filling in color

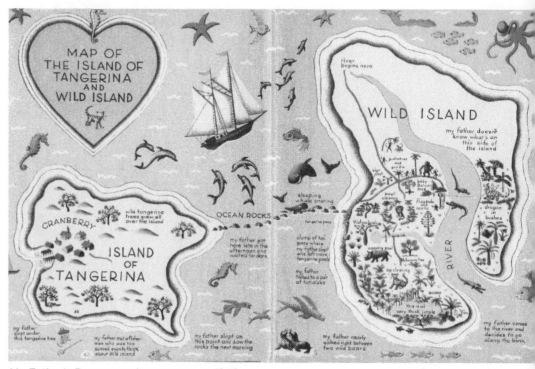

My Father's Dragon *endpaper map, c. 1948*

Some of the most memorable maps from childhood are endpaper maps found on the inside covers of our most beloved books. *My Father's Dragon*, a fanciful tale of travel to the fictional islands of Tangerina and Wild Island, featured an intriguing endpaper map. It is labeled with the places where many adventures took place, including where Father talked to porpoises and the flagpole and crank where he kept his dragon tethered.

Story maps invite the reader in. These story maps—from books and past TV programs—offer up the opportunity to live in another world, fictional and beloved. Story maps also provide a chance for interpretation, a creative opportunity for entering and reinterpreting the stories you love best.

INSTRUCTIONS

1. Using your story, make a list of place names and setting details and, if possible, their relationship to each other. Make a note of any cardinal directions given.

2. Decide on the setting that most intrigues you. Many stories have more than one. Pick the level of detail you'd like to include.

3. On art paper, sketch the roads, buildings, and geographical features in pencil.

4. Outline your sketch in pen.

5. Paint in your drawing.

6. Label the known areas.

7. Make a title that refers to the story. (Right)

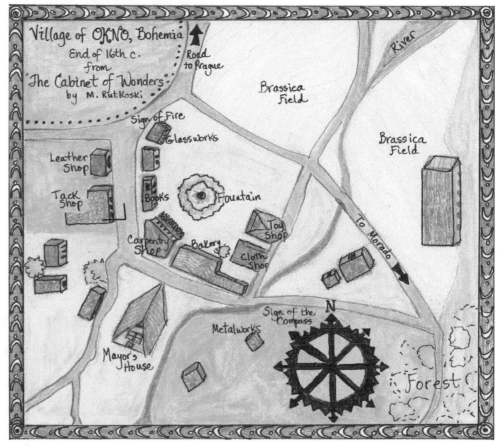

Imagined map of Okno from The Cabinet of Wonders

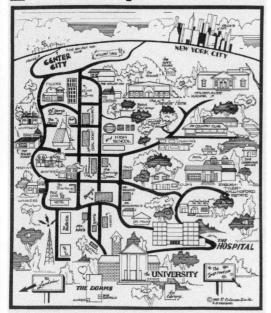

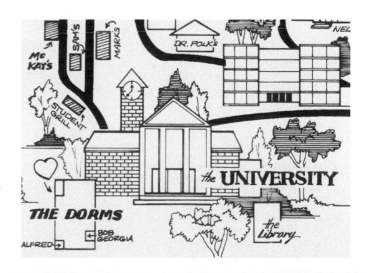

Imagined Pine Valley from a T.V. soap opera (left)

Pine Valley, detail (right)

CUSTOM CONSTELLATIONS

MATERIALS

→ Images for inspiration and copying

→ Watercolor paper

→ Pencil

→ Small star stickers

→ Watercolors

→ Watercolor brushes

→ Waterproof pen, such as a Micron

In the second century C.E., Ptolemy, an astrologer and cartographer, attempted to map the sky. He recorded the positions of the stars, described them, and named them as 48 constellations. Here you see one of his constellations as illustrated in London, in about 1825, with the descriptions of the characters in each set of stars.

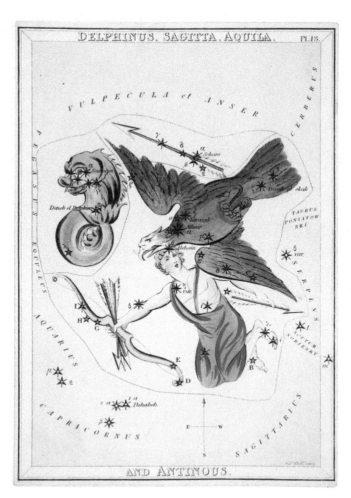

Delphinus, Sagitta, Aquila, and Antinous. Best seen in the early evening in August.

Delphinus (the dolphin) looks a little like a sea monster.

Aquila (the eagle) represents a mythological bird, Jupiter's companion.

Sagitta (the arrow) is the third smallest constellation in the sky.

Antinous (the woman) was a lover of the Roman emperor Hadrian.

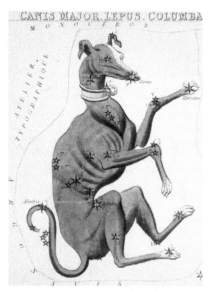

Canis Major is said to represent the dog Laelaps, a gift from Zeus to Europa.

INSTRUCTIONS

Fig. 1

Fig. 2

Fig. 3

Fig. 4

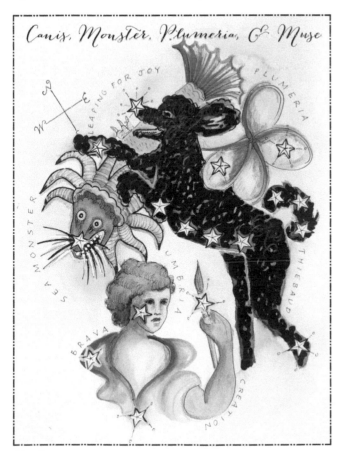

Fig. 5

1. Think of a simple story with three to five characters of your choosing.

2. Make a list of characters. Mine include my dog, sea monsters, tropical flowers, and my muse.

3. Collect images to copy for the drawing. (Fig. 1)

4. On watercolor paper, draw a simple outline of the images in pencil, arranging them on the page in a pleasing way.

5. Decide where the stars will go and stick them on the page. (Fig. 2)

6. Paint around and over the stars to define their borders. (Fig. 3)

7. Let dry completely, then remove the star stickers.

8. Outline the figures with black pen and add text with a waterproof pen. (Fig. 4)

9. Name your constellation. (Fig. 5)

MATERIALS

→ Pad of paper

→ Pencil

→ Paper for drawing

→ Coloring materials

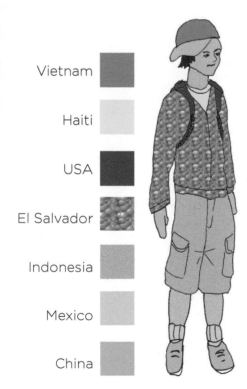

Vietnam

Haiti

USA

El Salvador

Indonesia

Mexico

China

Some maps are not about explorations of places you have been or want to go; they represent a story of a different kind. This is a map of sources, origins, or beginnings. You are going to do a bit of research for this one, and you will likely learn a lot!

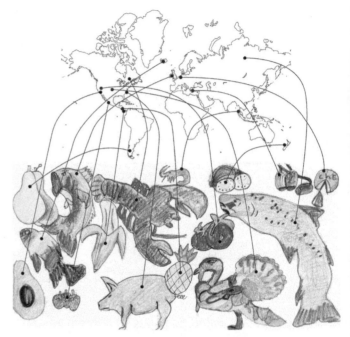

Sam Berry wondered one day where his food came from. He heard lots of folks talking about the importance of buying locally, and his family participated in a CSA (community supported agriculture) program with a small nearby farm.

Imagine how surprised Sam was when he went to his local organic grocery to find out where the food he ate originated and discovered almost none of it was local! The bass came from Iceland, salmon from Scotland, kiwi fruit from New Zealand, and so on. (Above)

Then he moved on to his clothes and, sure enough, only one item of his outfit was made in his country. (Left)

Where do the things around you come from?

INSTRUCTIONS

1. Pick a subject for this research. You are going to be trying to find the origin of your subject. Here are some ideas:

 a. Your neighbors' hometowns
 b. The birthplaces of your relatives
 c. Where sports equipment is made
 d. The manufacturing place of household goods

2. List your items and their origins.

3. Photocopy and enlarge the map above onto drawing paper and mark the places of origin on the map with the coloring materials of your choice.

4. You can also draw your items like the examples on the left, or use photos and draw the line from the photo to the map above.

⪼ TAKE IT FURTHER ⪻

Pick a magazine photo of an athlete or a movie star and try to figure out where his or her clothes and equipment came from.

LAB №21 WORD MAP

MATERIALS

→ Black or white paper

→ Maps to trace or copy for outlines

→ Pens or pencils of different colors

Making a map of words is a combination of journal techniques and geography. It helps you understand and appreciate all that you see in a place and how you feel about it. The word maps here helped me appreciate each trip I took because I had to recall events, geography, culture, and feelings I had for each place.

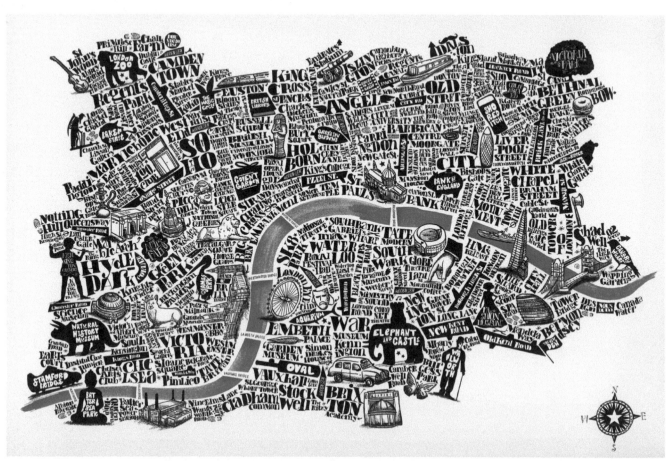

João Lauro Fonte's map of London

If you are using black paper, you need to use opaque inks or pencils (this means that they are not transparent). There are also opaque crayons that are made for construction paper that would be perfect for this technique.

1. Outline your place lightly on your paper.

2. Note borders and beaches, like I did on the map of Guatemala (top right). *La playa* means "the beach" in Spanish.

3. Make a list of words that describe your trip to the place or, if it is an imaginary place, what you might like to see there. I added "Jamaica," which is a drink of hibiscus tea that I learned to love in Guatemala. I was there during *Semana Santa*, or Holy Week, so I added words that applied to my experience, such as *pageantry* and *Pascua* (Easter).

4. Add the words in different sizes and colors until you fill up your outline.

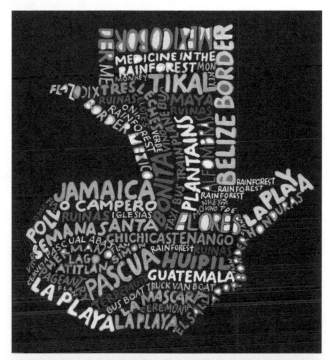

On the map of New Orleans (bottom right), I did some journaling about the things I heard in the aftermath of Hurricane Katrina, the storm that devastated the city in 2005. The red area is where the water was highest. I collected stories that people told, both harrowing and heartwarming tales. It was cathartic to make this map in the same way that journaling serves as a creative release. I call it *Aftermath Map*.

Artist João Lauro Fonte designed this typographic map for Converse UK to communicate little hidden gems in London (left), encouraging people to see the city through a different angle and explore off-the-beaten-path places. The map highlights some of London's main attractions and presents some hidden nightclubs, bars, galleries, and cinemas that Converse thought its audience should know about.

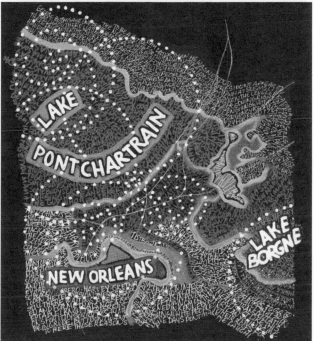

❧ MATERIALS ❧

→ Pastel paper or paper appropriate for your medium

→ PanPastels (or crayons, collage, or paint of all kinds)

→ PanPastel shaped sponges or appropriate tools

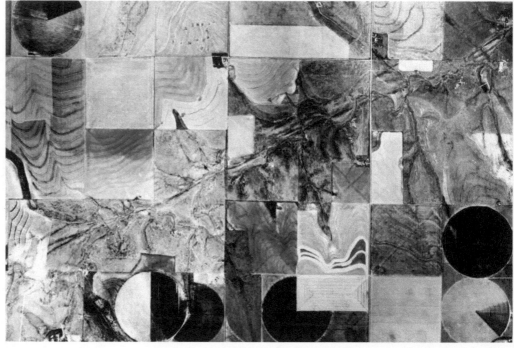

Digital patchwork of Kansas prairie on Google Earth

My house on Google

With the advent of Google Earth and applications like it, you now can have aerial views without leaving the house. Just type in an address, "fly" there via a computer, and enjoy a bird's-eye view of almost anywhere on the planet. Head to Paris, Madrid, or Rome!

In this project you'll take those views, and using PanPastels and their companion tools (or any medium you like), you'll paint an abstract bird's-eye map.

Painting of my family's house

~§ INSTRUCTIONS §~

1. Find an image on Google Earth and print it out. (Fig. 1)

2. On your paper, lay in the dark area. Squint your eyes to see this in a simpler way. Then, using your lightest color, lay in the brightest areas to balance the composition. (Fig. 2)

3. Decide on your basic color areas and color them in. Think of the first layer as a coloring book page, putting a simple color in every section. At the end of this stage, you have finished what is called the "underpainting."

4. Try to see the picture as a series of geometric and curvilinear spaces. A house, for example, is a series of rectangles as seen from the sky. Trees can be circles. Tell yourself you are painting patterns instead of a whole neighborhood and it will be easier to approach.

5. Add the colors you like, even if they are not on your photo. The samples shows lavender and teal in the trees, and pink in the dirt. (Fig. 3)

6. Imagine hovering over this place, and seeing the sparkling color details that you miss in a photo. Add those in. You will see tiny sparks of color near two of the buildings because they are porches where people gather.

7. Add colors until you are satisfied. You will end up with an abstract and luminous landscape as seen from the sky. (Fig. 4)

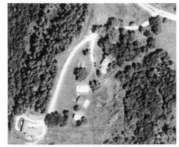
Fig. 1

Fig. 2

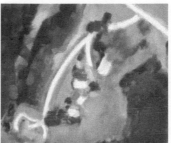
Fig. 3

Fig. 4

My family's ranch on Google

Pastel of my family's ranch from a Google image

THE ROAD TO SUCCESS

MATERIALS

→ Map style of your choice

→ Drawing paper

→ Pencil

→ Ink pen

→ Watercolor pencils or fine point marker

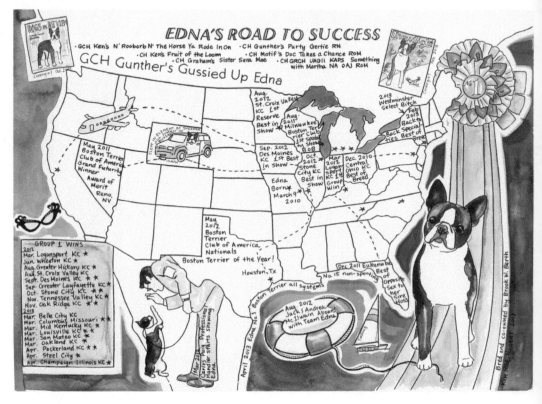

Success can be obvious, like winning a national spelling bee, or subtle, like getting through a tough year. Often our successes are not the result of a planned, straight-as-an-arrow path. For Edna, who is featured here (above), her birthplace in the Midwest served as the hub of her journey toward dog show excellence as she crisscrossed the United States. Artist Kim Rae Nugent really captured the charm and richness of this pooch's progress. Edna is her grand-dog.

There are many ways to map your road to success. Finding the right one is a matter of first considering what kind of journey it was. Here are a few ideas on mapping your Road to Success.

INSTRUCTIONS

1. Make a list of people, places, and things that are part of your journey

2. Select a map style that matches your unique journey. Sketch the shape.

3. Insert the important people or things along the way. Sketch in or trace imagery.

4. Insert obstacles you overcame or avoided.

5. Ink in all the details.

6. Color as desired.

1. **Metro.** The metro map is a journey of junctions and new directions. Design it with all the influences, alternatives you considered, and even a dead end or two.

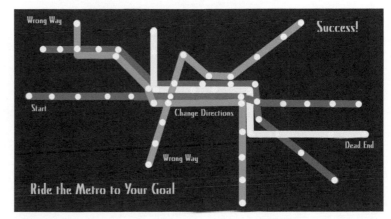

Metro

2. **Game Board.** On this map, you can show where you started, what you encountered along the way, and your final success at the center.

3. **Before and After.** This map shows simple drawings of your starting point and path, using icons or clip art.

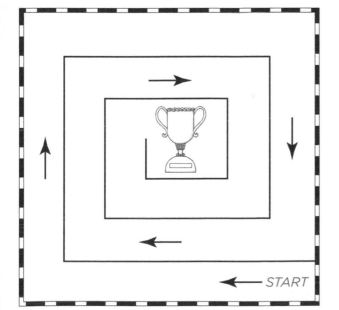

Game Board

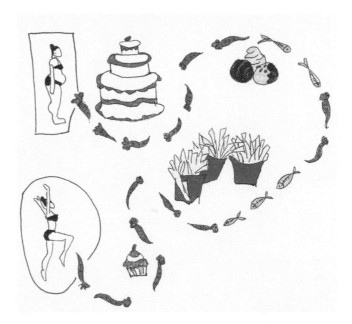

Before and After

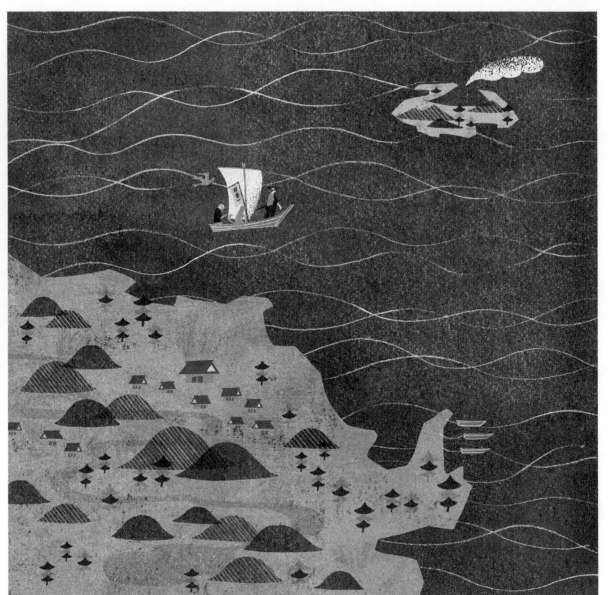

Momotaro, Little Peach

This is a map of a Japanese fairy tale, Momotaro. Momotaro, the main character, was born from a large peach floating down the river. In this map, he sets sail for the island of wicked ogres with his fellow animals.

Masako Kubo is an illustrator from Japan. After receiving a non-art–related degree and working for several years in Tokyo, she took the plunge and followed her dream of being an illustrator. She went to England to do a second degree in illustration, and since then she has been illustrating for various clients both in and outside Japan.

Mapmaking is one of her favorite types of activities. She likes maps because they contain a lot of information packed in a small space, often in a very interesting and clever way. These maps are a mixture of handmade textures, drawings, and shapes assembled on a computer. She likes printmaking, and as you can see, she uses textures in many pieces. She often creates maps, small and large, for her clients. Kubo creates some works entirely by hand, but they are usually limited to personal pieces.

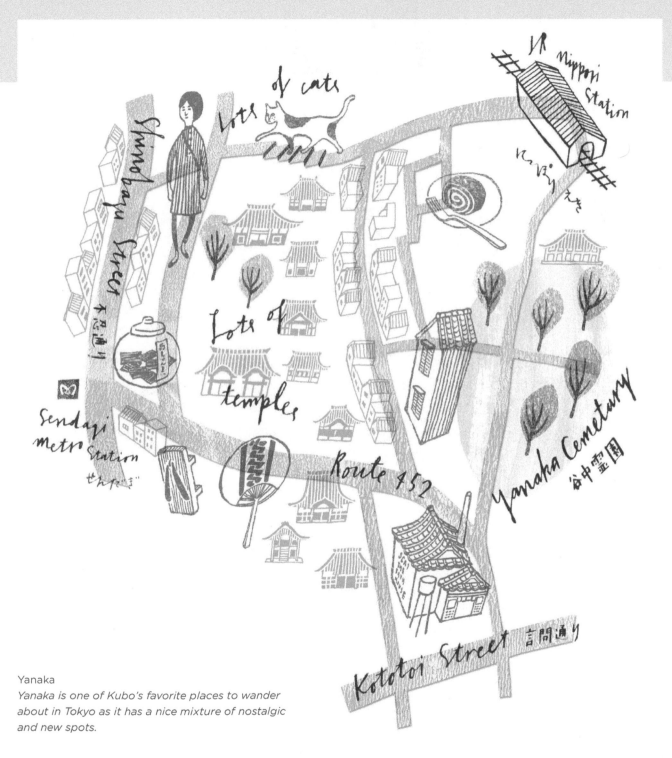

Yanaka
Yanaka is one of Kubo's favorite places to wander about in Tokyo as it has a nice mixture of nostalgic and new spots.

MIXED-MEDIA MAPS

As you can see by the evidence in this book, maps can be and have been made out of almost anything. In this section, they are more than flat maps drawn on paper. They are upcycled, started from materials from the hardware store, garage sales, and easily found craft items. They are made from goods gathered at home, personal treasures, and rocks from the riverside.

The hope is that the ideas in this chapter will get you out there looking for unusual items to fashion into three-dimensional illustrative journeys. Dig through the castoffs of construction sites and recycle and bargain bins to find fodder for your mixed-media cartographic projects. The sky is the limit!

"In my writing I am acting as a mapmaker, an explorer of psychic areas, a cosmonaut of inner space, and I see no point in exploring areas that have already been thoroughly surveyed."

—William S. Burroughs

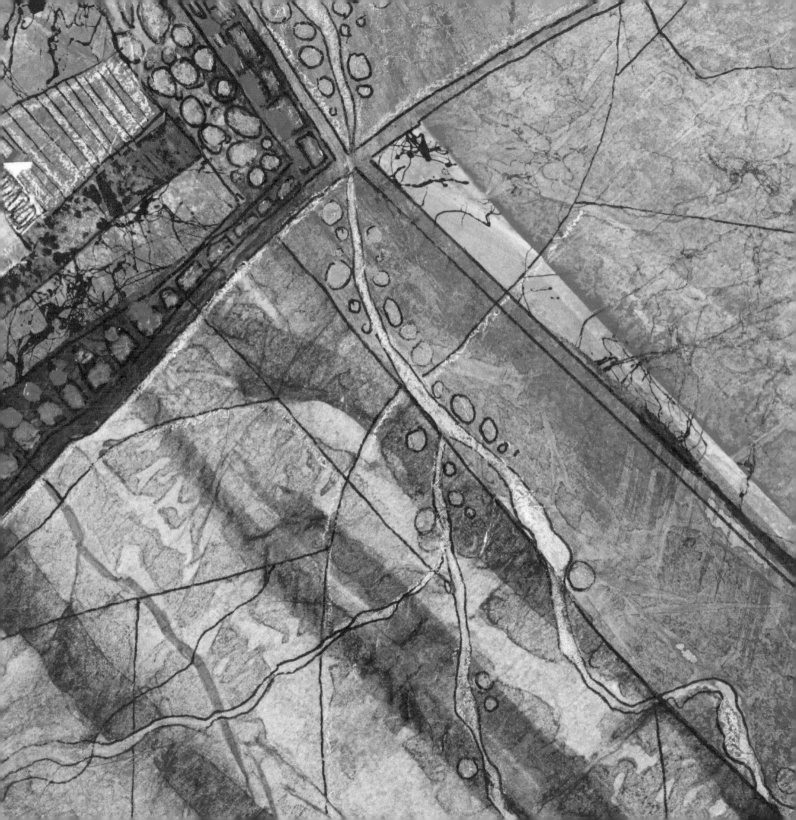

UPCYCLED ADVENTURES

✦ MATERIALS ✦

→ Brochures and maps from a trip or an experience

→ Glue

→ Art Paper

→ Marking pens

→ Colored pencils

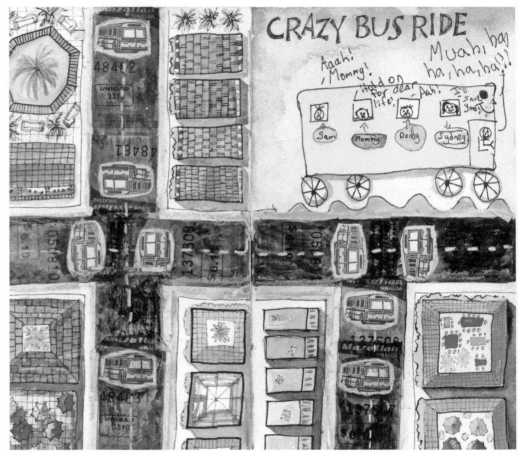

Crazy Bus Ride

Bright Lights, Odd City

San Diego Graduation

If you come home from vacation with a bag of brochures, maps, and postcards, this is the project for you! These maps are made about your vacation or experience from the ephemeral fodder you gathered while having it.

For example, my family took a trip to Mexico, where we rode quite a few local buses. One day we had a bus driver who must have longed to be a racecar driver. He drove so fast and clipped the turns so close that all the foreign passengers were screaming (the locals were quite blasé). We called it Crazy Bus Ride, and my daughter and I made this map (above) out of all our leftover bus tickets.

The bus tickets were glued on to become the streets and painted over lightly so the bus printed on the ticket was still visible. The streets are not an accurate rendition of that trip, but rather a colorful representation. The buildings and fauna are drawn to capture the flavor of Mexico.

The city of Boulder, Colorado, is one of many cities well known for its coffeehouses. The map of those coffeehouses comes from one found online, and many of the coffeehouses were gathered in a perfect oval, or the top of a cappuccino cup, in the area of downtown Boulder called Pearl Street. Pearl Street is a walking mall, and along the way there are charming places to stop for an espresso or chai, so I went to four of them to try them out.

My husband and I both graduated from a university in San Diego, as did many of our friends. It seemed an obvious thing to celebrate one of those graduations with this map (bottom, opposite) of San Diego, with the outline of a mortarboard.

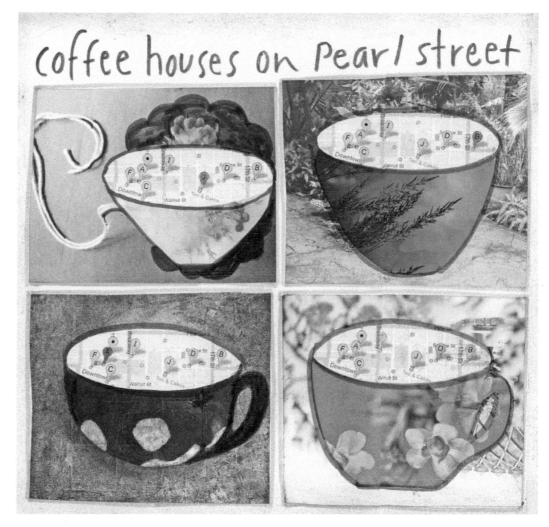

1. Start with a brochure or guide from a place you visited. Take a part of that map and glue it down on paper.

2. Collage or paint around the part of the map you want to keep.

3. Continue some of the lines on the map and add commentary. None of this has to be accurate at all. Make it playful: Jot down things you ate, what you saw, or some of the lyrics of a song you might have heard while there. (Bright Lights, Odd City)

MATERIALS

→ Secondhand wooden bowl

→ Sketch paper

→ Pencil

→ Scissors

→ White glue

→ Tissue paper, plain and patterned

→ Acrylic paint

→ Paintbrushes

Two Sides, *Amy Smith*

This lab features unique maps of homes painted or collaged onto upcycled wooden bowls or other used household items. Look for wooden/paintable housewares such as trays, cutting boards, or plates at garage sales. Painting a map of your home or neighborhood on a household object turns an ordinary thing headed for the landfill into a decorative, nostalgic art piece. (Note: Don't use your piece for food service after painting!)

1. Trace the bowl onto the sketch paper for an approximate size of your map.

2. Sketch the places you see as vital on your map with pencil. Don't worry about scale. You can place the paper inside the bowl to see how the elements of your map work on the curved surface.

3. Duplicate your sketch inside the bowl, adjusting as necessary.

4. Cut, shape, and glue in tissue paper where desired.

5. Paint on the wood and tissue, If you like the effect.

6. Embellish the edges, sides, and bottom with tissue and paint.

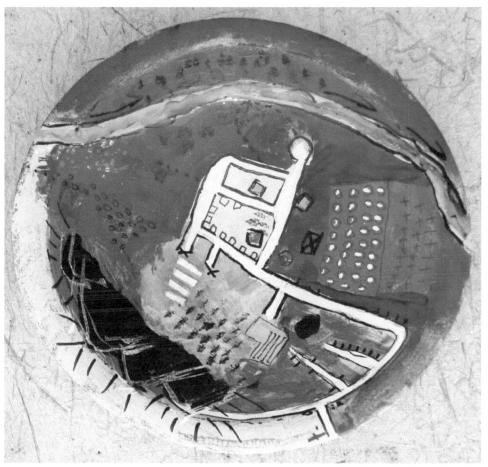

Hometown, *Amy Smith*
Hometown *is a map of the small town where artist Amy Smith grew up. It features special places from her childhood: the purple mountains, her home, the homes of her best friends, and the town swimming pool. The dashed line leading from the paved roads to the woods is the path she took to find solitude sitting on a rock beside the creek.*

Escape Place, *Amy Smith*
Escape Place *shows a line of identical houses along one side of the road. They represent "normal" cookie cutter living. The arrows around the edge show the futility of going in circles trying to fit in. There is an X that marks the place where one can get off the beaten path to escape the boredom of sameness and doing what is expected.*

Escape Place, *Amy Smith*

TEA-DYED TREASURE MAP

❖ MATERIALS ❖

→ 2 cupfuls of very strong black tea (four times normal strength)

→ Edged cookie tray or other flat, low container for liquid

→ Dark pencil, HB or softer

→ Art paper that can take moisture (e.g., Arches Text Wove)

→ Paper towels

→ Black pen, medium point

→ List of "pirate" terms and icons, such as *swashbuckling, booty, smuggler, treasure, shipwreck, mutiny, cutthroat, bloodthirsty, Jolly Roger,* etc.—the wilder, the better.

→ Pirate-related icons or symbols to trace or copy

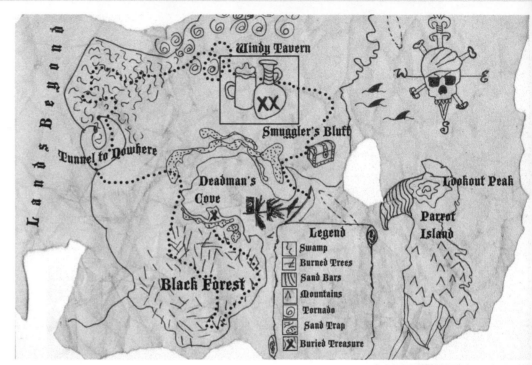

Real pirate maps are rare, since swashbucklers would sooner cast their maps and treasure into the sea than give it up to another cutthroat. In this project, imagining the ruthless ways a dastardly pirate would hide his ill-gotten treasures from others is most of the fun. Follow if ye dare, Matey!

INSTRUCTIONS

1. Pour the tea into the cookie sheet and let cool.

2. Draw your map in dark pencil on art paper. Include treacherous areas and an X for the treasure spot.

3. Crumple the map. The more creases, the better. Open and tear the edges carefully. Tear a couple of holes, avoiding important areas. (Fig. 1, 2)

4. Immerse the map in the tea. Let it sit for several hours or overnight until the desired darkness is achieved. Leaving areas above the liquid will draw the fluid up to make "mountain ranges." (Fig. 3)

5. Carefully remove and place your map on paper towels to dry. Do not smooth. (Fig. 4)

6. Trace your pencil with black pen and add a legend, pirate terms, icons, and a dotted line for the path to the treasure, as shown in the example opposite.

Fig. 1

Fig. 2

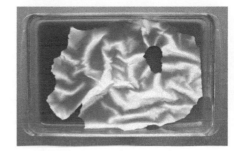
Fig. 3

Fig. 4

⚓ HISTORY TIDBIT ⚓

Piracy began more than 2,000 years ago in ancient Greece, when sea robbers threatened trading routes. The threat continued among seafaring nations until the birth of regular navies. However, piracy really flourished between 1620 and 1720, and this period is known as the golden age of piracy, in part because the life of a pirate was more profitable and comfortable than being a merchant seaman.

Daredevil women joined the ships disguised as men. But in the eighteenth century, Ching Shih from China rocked the pirate world by commanding—as a woman—a ruthless collection of swashbuckling followers numbering 80,000 with whom she defeated the Chinese navy.

Pirates sometimes tipped their hand by flying the Jolly Roger, a black flag with white skull and crossed swords, a bold logo that identified them to potential victims on passing merchant ships. It was an adaptation of a skull and crossbones, used in ships' logs to symbolize a death aboard.

If a pirate stole from his or her fellow buccaneers, they tossed the thief's sorry self out with nearly nothing onto a desert island.

TESSELLATING TILES

* MATERIALS *

→ Ruler

→ Pencil

→ Square white paper (6 or more sheets)

→ Watercolor crayons

* TAKE IT FURTHER *

Tessellating map squares look beautiful on ceramic tiles. Cathy Taylor used a colorful palette to make a garden map based on Butchart Gardens in Victoria, British Columbia, that can be rearranged in several different ways to please the eye. (Opposite, bottom right)

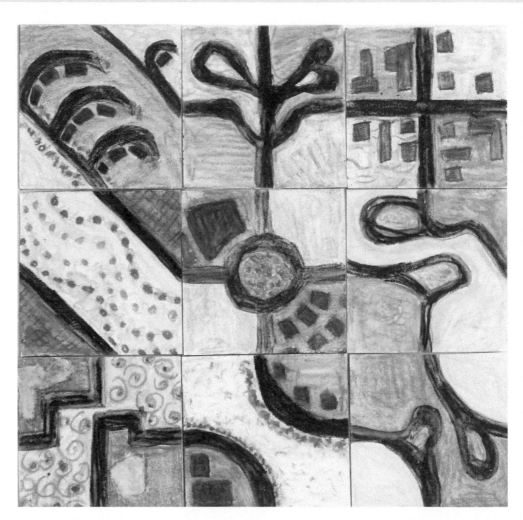

A tessellation is a repeated geometric form fitted so that no gaps or holes are left. Floor tiles and quilted shapes are familiar examples of tessellations. Artists and architects have been making tessellations for centuries, starting several thousand years ago in early Sumerian homes and temples decorated with repeating ceramic designs.

Modern-day tessellations can push the boundaries of true tessellations by having only certain elements in common. In this project, each tile is unique but interchangeable, which produces a different result with every new combination.

Fig. 1

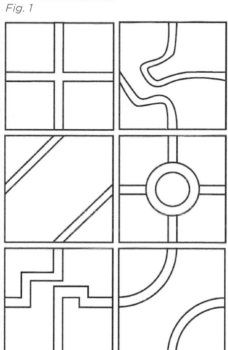

Fig. 2

Fig. 3

1. With a ruler and pencil, mark the center point of each square edge. Measure an equal distance on either side of this to mark a width you'd like for your roads (about finger width). These are your four road entrances and exits. (Fig. 1)

2. Design roads that travel from any one side to any other side, using all four sides of each square. Your roads may go in a diagonal, meander, cross in the center, form a circle, or whatever else you can dream up. They could even loop back and rejoin themselves to exit the same way. Keep the width of the roads consistent and use all four sides of each square. (Fig. 2)

3. Color in the roads black. You may add dotted lines down the center if you wish. Be sure to color to the very edge of the paper.

4. In the remaining spaces, completely fill in the other four areas with green in two diagonal corners and brown in the other diagonal corners. Textures are fun here and you can also add mappish features such as water, flowers, or buildings. Just be sure to color in all of it and keep the colors in diagonal pairs. (Fig. 3)

5. Now, see how many ways you can position the squares. You can make tessellations as a group and mix and match to make dynamic maps. (Fig. 4 and opposite)

Fig. 4

❖ MATERIALS ❖

→ 12-inch (30.5 cm) piece of craft wire, or cut the bottom off a thin coat hanger

→ Styrofoam ball

→ Dowel or rounded rod

→ Glue

→ Small dish

→ Lightweight solid-colored tissue: Paint some white art tissue with colors and spray on textures or use any paper in small pieces

→ Lightweight printed papers: Use printed tissue from shopping and gift bags and old dictionary pages

→ Paintbrushes

→ Iridescent paints

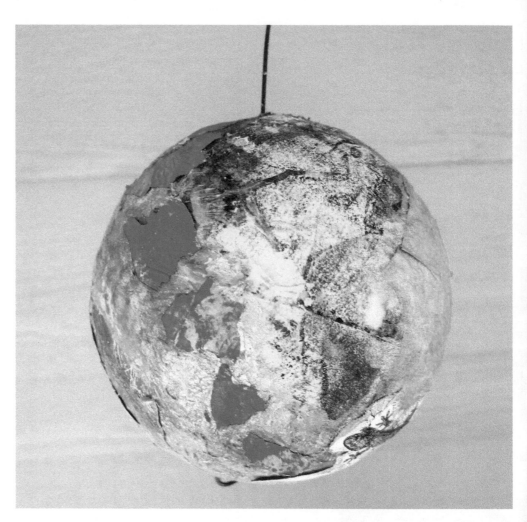

When we were in elementary school, we had a project called "Imaginary Continent" in social studies class. We had to invent a continent, make it out of plaster on a board, then assign it a climate, political system, and all the details a new continent needs.

In this case, you will invent an entire world, but one that revolves around you.

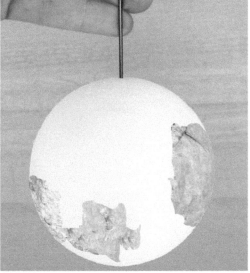

Fig. 1

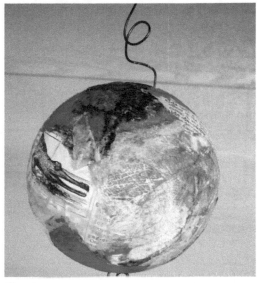

Fig. 3

Fig. 4

Fig. 2

1. Poke the wire piece through the middle of your styrofoam ball. Wrap the wire around a dowel or something rounded to make curves in the wire. Make a spiral at the bottom to keep the wire from falling out. Do this first so you have a handle to hold on to while the planet is wet and so you keep the orientation you want. (Fig. 1)

2. Put the glue in a small dish or cup. It should be wet but not runny. If it is too runny, let it get tackier overnight before you use it.

3. Tear up your papers; don't cut them. Organic shapes are what we are after. (Fig. 2)

4. Collage your papers on, starting with the color you will use most. We used blue for the ocean. Paint the glue on with the paintbrush, then apply small pieces of papers on one at a time so you don't get wrinkled clumps. (Fig. 3)

5. Add layers for continents, islands, and anything else. We added some critters from an old dictionary.

6. Decide which land will be yours. We picked a series of red islands that go north and south of the equator

because we wanted as much variation in temperature as possible, and temperatures are generally hotter toward the equator and colder toward polar regions. Plus, we are in love with the sea, so we wanted as much seacoast as possible.

7. Brush shiny, glittery paint on some of the water areas to add shimmer and contrast.

8. Name your planet. This one is Gaia Land, after the Greek goddess Gaia, the personification of the earth. (Fig. 4)

❧ MATERIALS ❧

→ Pencil

→ Sketch paper

→ Fabric, such as felt, cotton, or wool in overall pattern or solids

→ Scissors

→ Embellishments, such as embroidery thread, yarn, beads, buttons, or sequins

→ White glue

→ Sewing needles and thread

→ Tag board or thicker fabric backing

→ Spray adhesive

NEW FOUNDLAND.

Until fairly recently, needle skills were considered an important part of a girl's education. Girls learned a variety of stitches and embellishments that they would need later as the seamstresses of their families. During formal schooling, stitching was combined with the other subjects and samplers showing alphabets and maps began to appear. Families framed and displayed this stitched art to entice suitors.

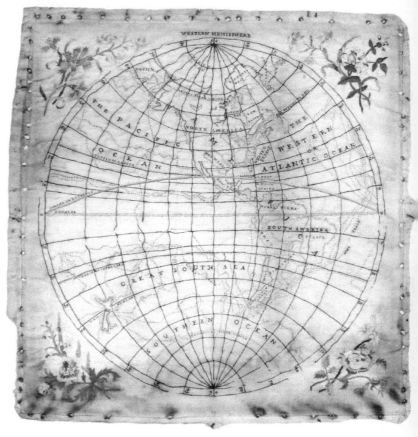

Some stitched maps from the nineteenth century were extraordinarily detailed, with lettering embroidered with fine threads or rich fibers. Cartouches were embroidered with the maker's name, the date, and the title of the map. These embroidered maps were most popular from the 1770s to the 1840s.

This beautiful linen and silk stitched world map attributed to Elizabeth Cook, wife of seafaring captain James Cook, was made sometime after her famous husband's expeditions, which took place between 1768 and 1779. It shows the tracks of his voyages as he circumnavigated the world, mapping countries and continents for the first time. (Above)

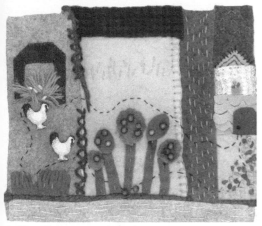

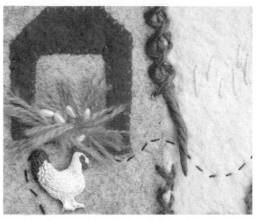

This stitched map is a nostalgic portrayal of our mother's childhood journey to retrieve eggs from her grandmother's henhouse, a special thrill for a small city girl. The track shows a meandering route to and from the henhouse, with detours through the apple orchard and flower garden. The details of the lacy curtain and house shingles give the map nostalgia, and the eggs are made of tiny pearl buttons. (Fig. 3)

A City Girl's Journey to the Henhouse

Detail of A City Girls Journey to the Henhouse

INSTRUCTIONS

Fig. 1

Fig. 2

Fig. 3

1. Using pencil and paper, sketch your intended map scene.

2. Audition fabrics until you are pleased with the combination.

3. Cut out the shapes you need. You can cut apart your sketch to use as a template or just refer to the sketch as a guide. You may leave edges raw or tuck them under to make them clean. (Fig. 1)

4. Add embellishments and shapes that bring the scene to life. (Fig. 2)

5. Glue or stitch together existing pieces, but don't glue down to a backing. Stitch the trail or map. (Fig. 3)

6. Finish by mounting on tag board with spray adhesive or adding thicker fabric backing.

✤ MATERIALS ✤

→ Transparency paper

→ Paint

→ Paintbrushes

→ Plywood a little larger than the size of your map and frame

→ Projector (optional)

→ Recycled ceramic and glass tiles

→ Shells, buttons, beads

→ Small stones

→ Beach pebbles

→ Beach sand

→ Colored glass

→ Necklaces and earrings

→ Broken plates, cups, and bowls

→ Christmas decorations

→ Personal mementos

→ Glue

→ Tile grout

→ Sponge

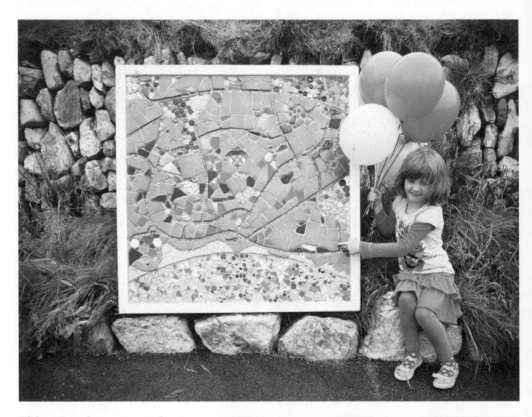

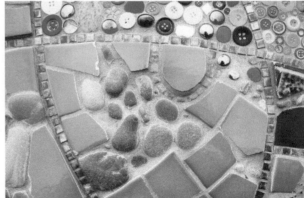

This mosaic map project was undertaken by Sean Corcoran and the pupils and staff of Knockmahon National School in Ireland. They decided as a group how big the map would be and that all the materials used would be upcycled and contributed by the pupils. They wanted to include the location of everyone's home in the map.

1. Study design and mosaics from around the world.

2. Study a wide variety of printed maps.

3. Learn how to use Google Earth (see Lab 22) to find the location of everyone's home.

4. Make a prototype map of all the features in the area, allowing artistic license for scale and proportion to make everything fit. Make this map on a transparency so you can project it later.

5. Paint the plywood backing board and frame the size of your finished map, plus a margin around.

6. Project and trace the completed layout of the map onto the board. Or transfer the map to the board by copying.

7. Gather all the recycledm aterials. Glue them to the board, composing shapes, textures, and colors to look like a map.

8. Grout and clean your map with a sponge.

9. Hang and enjoy!

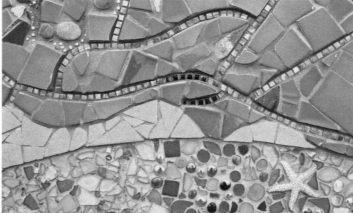

Mosaic map detail

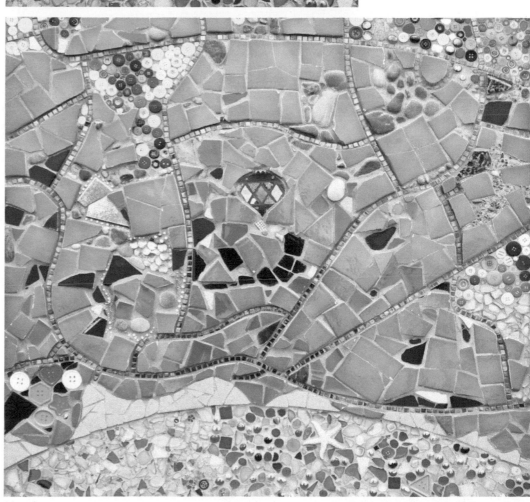

Mosaic map

MIXED-MEDIA MAPS

Susan Corl, a visual folk artist, received an Arts Learning Grant from the Arizona Commission on the Arts to conduct a two-week artist-in-residence at Many Farms High School in the Navajo Nation in Arizona. She worked with 120 students making personal geography mixed-media maps. Corl shared her knowledge of sewing skills (hand and machine) with the teenagers. Students could choose to map a trip, where they live, a memorable event, or where their feet had been in the last week. Collaged paper cloth was the foundation using upcycled papers, fabric, and threads. Embroidered stitches, sewing notions, and decorative machine stitching added a three-dimensional component to their work. Many of the students sewed for the first time on this project.

Here is the map she made as a sample for the students. (Right)

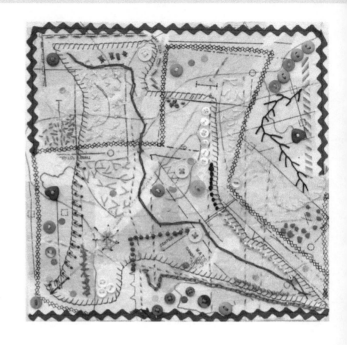

Jonessa Price mapped the important places she had been within the week.

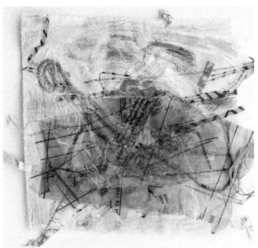

Demetria Cowboy is a student who is differently abled, with extremely expressive artwork in color and shapes.

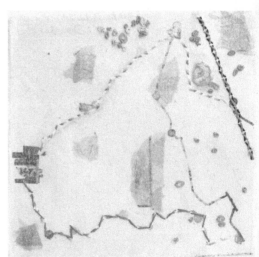

Anonymous student #1 mapped a trip she took with her mother and brother to visit her dad in Douglas, Arizona.

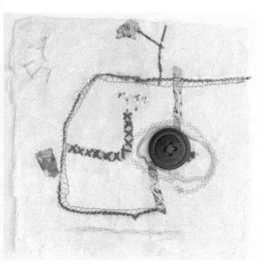

Trenton Begay created a map of where he lives in Tsaile. The colored papers are buildings, houses, and schools. The maroon button represents Diné College in Tsaile.

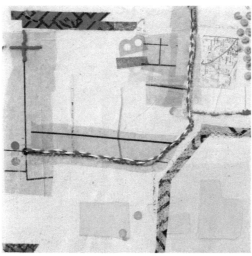

Angel Mark's map shows a specific, personal side of Chinle.

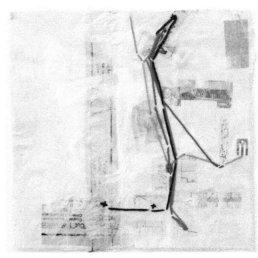

Anonymous student #2 created a map of a previous year's class schedule.

Caronda Yazzie thought it would be fun to have people see where she walks every day to her classes and lunch.

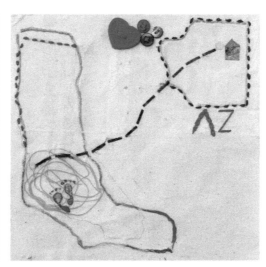

Jordan Cooke mapped a memory of a trip to California.

Dorius Nakaidinae mapped where his feet had been going to classes Monday through Friday.

PERSONAL MAPS

There is a long historic tradition of making personal maps. In fact, one could go as far as to say that all maps are personal, because they each have a maker with a story to tell.

Nearly every structure in this book can be made into a personal map, meaning a map of your stories, dreams, and experiences, whether real or imagined. Climbing through memories in order to map them is a rich learning experience that may leave you full of wonder and nostalgia or rolling on the floor remembering hilarious adventures.

"Regular maps have few surprises: their contour lines reveal where the Andes are, and are reasonably clear. More precious, though, are the unpublished maps we make ourselves, of our city, our place, our daily world, our life; those maps of our private world we use every day; here I was happy, in that place I left my coat behind after a party, that is where I met my love; I cried there once, I was heartsore; but felt better round the corner once I saw the hills of Fife across the Forth, things of that sort, our personal memories, that make the private tapestry of our lives."

—Alexander McCall Smith, *Love Over Scotland*

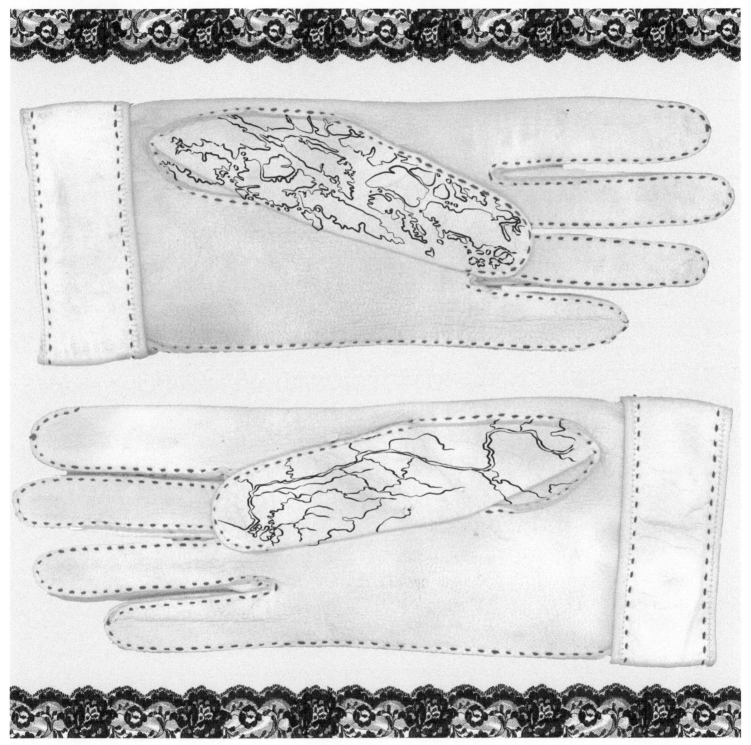

Our grandmother was a world traveler and a fashionable woman. I drew maps of her two favorite trips (the inside passage of Alaska and a Rhine River cruise) on the thumbs of her favorite pair of soft, Parisian, leather gloves.

MAP OF YOU AND ME

✦ MATERIALS ✦

→ Paper

→ Photos/maps

→ Colored pencils

→ Waterproof pen, such as a Micron

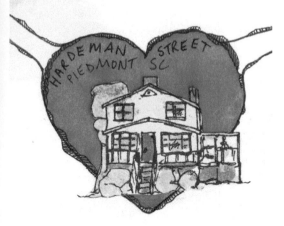

Sloan added a lot of detail in each drawing, hoping that the feeling of love and well-being would shine through.

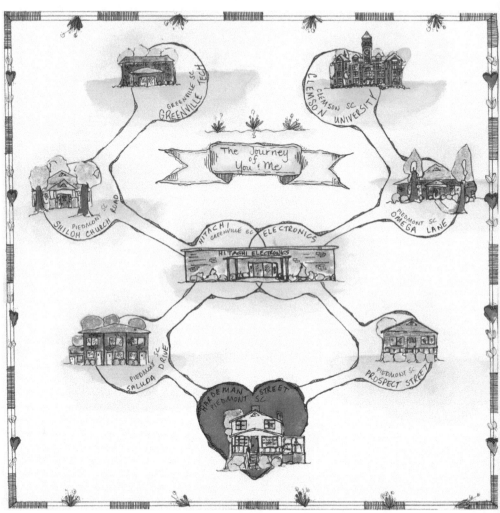

Journey of You and Me

Mapping the relationships you have with another person or creature is enlightening and fun. It can be anyone: your best friend, spouse or love interest, neighbor, coworker, colleague, even pet! This map can be drawn or collaged with maps and photos that are applicable to your relationship.

Artist Carol Sloan made a map of her romantic journey with her husband. It's a progression of the places they lived, beginning with their college years.

INSTRUCTIONS

1. Pick a treasured person or pet to work with.

2. Make some notes about you. Where did you start in this relationship—at birth? In your twenties?

3. Make some notes about your partner. Start at about the year you did with yourself, so the relationship is parallel.

4. Make notes about things, places, and events you have in common.

5. Sketch out the map by starting in one corner with your journey, and in the other with your partner's. You can also start at the top or bottom and create a trail that leads you together.

A trail from me to you map idea

A boy and his dog map idea

6. Decide where the culmination of the map will be. It can be at the top, the bottom, or the center. Finish with colored pencils and waterproof pen.

HISTORY TIDBIT

Allegorical maps of love appeared in the 1700s and 1800s. Sometimes they outlined a journey through love and marriage, citing places such as Baby Land and Squabble Marsh. Others, like the one seen here, illustrate a more cynical view. *Carta Topografica dell'Isola del Maritaggio di Monsieur Le Noble* from 1765 appears to be adapted and translated from the Carte de l'Isle de Mariage by the prolific Eustache La Noble de Tennelière (1643—1711), first published in 1705. It presents the heart as a great fortress surrounded by the peninsula of Divorce and Mountains of In-Laws. (Right)

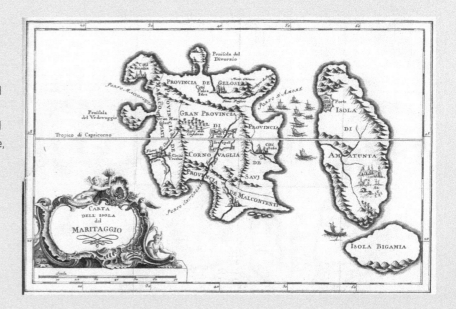

· MATERIALS ·

→ Pencil and scrap paper

→ Piece of sturdy, flexible painted paper

→ Grommets

→ Roundish bar or sticks

→ Ribbon

→ Scissors

→ Drawing utensils

→ Beads

· HISTORY TIDBIT ·

At the far right is a detail of Sebastian Adams's 1881 *Synchronological Chart of Universal History*, which is 23 feet long (the longest known timeline) and shows 5,885 years of history, from 4004 BCE to 1881 CE.

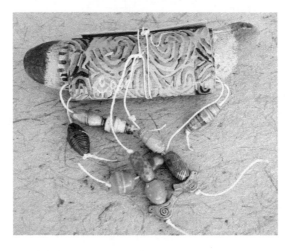

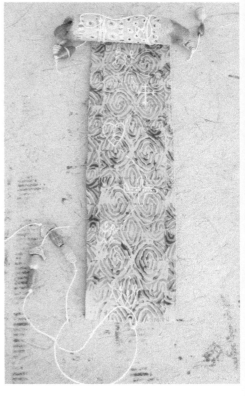

Mapping time has long been an interest of cartographers, and we are no exception. Visualizing historical events in a timeline is an effective way to show the passage of time and the events that unfold with it. This project combines two ideas: the scroll as a book form and the timeline, which is drawn inside of it.

Prayer Scroll (above) by (artist) Amy Smith was created for her adopted daughter from Ethiopia, who has been with the family for almost eight years and has begun to have questions about her birth family and country and how she came to be with the Smiths.

In Ethiopia there is a long tradition of people commissioning scrolls from priests or shamans for healing illness or anxiety, combining art and prayer. Smith's daughter's scroll depicts the family's journey to her, starting with their prayers for a daughter through finally bringing her home to meet her new big brother.

The scroll wraps around a piece of driftwood collected by Smith's paternal grandmother when she drove her RV from West Virginia to Alaska. Smith loves the continuity of the idea of family and the tradition of strong, adventurous women in her lineage that this piece of wood represents. Smith hopes that this scroll map of her story will give her daughter a deep sense of belonging and adventure.

Fig. 1

Fig. 2

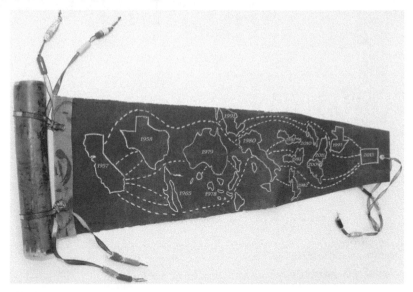

Fig. 3

1. Make a list of the steps in your timeline. Sketch them out on scrap paper before you commit to drawing on the painted paper.

2. Fold over one end of the scroll paper and set in two grommets or reinforced holes. Tie the scroll paper to the bar through the grommets using the ribbon. Leave enough ribbon to attach beads for decoration. (Fig. 1)

3. Cut the paper into a wedge shape before you begin so it is more attractive when rolled. Draw your timeline on the paper. This one is a history of travels from birth until the present day. (Fig. 2)

4. Fold over the small end of the scroll paper, set in a grommet, and tie on some ribbons and beads. (Fig. 3)

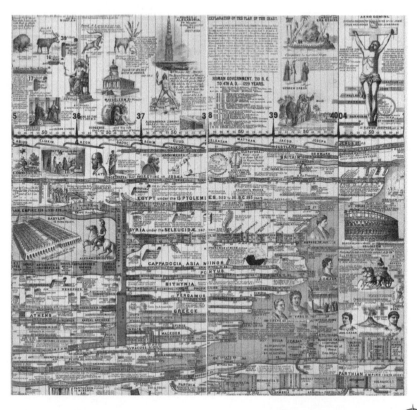

GETTING TO KNOW YOU: MAPPING TABLES AND DORMS

MATERIALS

→ Sketchbook

→ Pencil

→ Colored pencils

→ Waterproof pen, such as a Micron pen

"A map does not just chart, it unlocks and formulates meaning; it forms bridges between here and there, between disparate ideas that we did not know were previously connected."

—Reif Larsen,
The Selected Works of T.S. Spivet

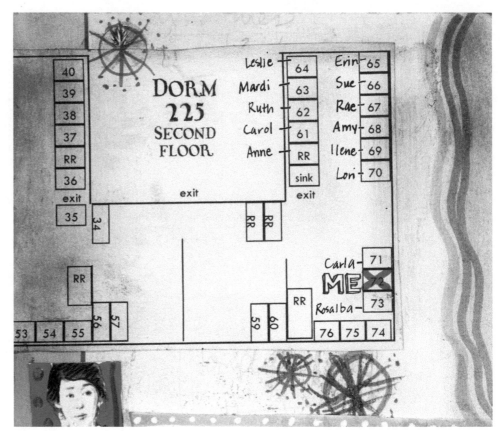

If you have a floor plan or map, simply fill in the names of those around you. You could even have your neighbors sign it.

Meeting lots of people in a new place can be both fun and overwhelming. You may find yourself dining at a table full of people you don't know. Here is a unique way—by map, of course—to combine getting to know people with remembering the event you shared.

You'll enjoy the conversation, make connections with those you are sitting with, have fun, and make art at the same time. Remembering your new friends will be that much easier. This activity is great for retreats and workshops, cabins at summer camp, weddings, corporate events, school cafeterias, reunions, campsites, and more. It's easiest to do this as a quick pencil sketch to color and embellish later.

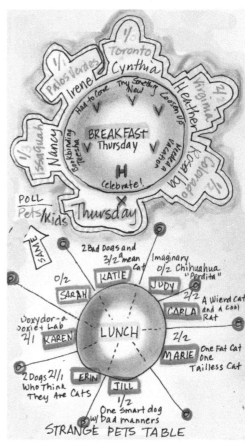

1. Draw the shape of the table on a scrap of paper or even a napkin. Put the names of the people at the table around the perimeter, where they are actually sitting.

2. Ask them a question and record their answers. The questions should have either a one word or a simple numerical answer.

Examples:
How many houses have you lived in?
How many pets/children do you have?
What is your favorite breakfast?
Who would you like to meet?
What would you rename yourself?

3. When you have time, redraw the table and add the names of the people you shared it with. Put their answers near their names. Add lines or colors to divide the seating areas and enclose each person's answers around the perimeter of the table. Add a title and date if you like, and finish with colors or borders. (See examples above.)

* MATERIALS *

→ Piece of paper or board (square is easy to start with)

→ Ruler

→ Various markers, pencils, or crayons

(Note: If you work on a stiffer surface, you could easily collage this map with ephemera from recent travels.)

Game pieces

Game boards have been produced around the world for hundreds of years, and most of them look like maps. You march your explorer around the board to win riches, property, or the enemy's army. This kind of map is a racecourse, and most of the time you must be the first to the finish line.

This is also a journey of simplicity, with one line from start to finish. In the case below, it is a journey from the airport to an art retreat, and all the things seen along the way.

Scenes and landmarks on the way to the retreat

INSTRUCTIONS

Fig. 1

1. Use the template on the left or make your own with a ruler. You can even trace the pattern on a game board that you have. (Fig. 1)

2. Draw or collage your journey in the tracks. Illustrations and directions are copied from brochures and photos collected along the way.

3. Add some arrows periodically to direct the eye.

Ideas for this map
1. From your house to work or school
2. A trip
3. Your day at work or school
4. How to reach your perfect self
5. The way to romance

BOARD GAME LORE

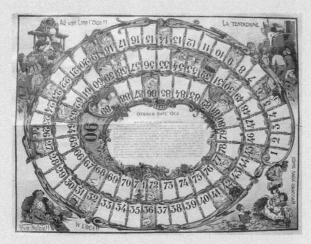

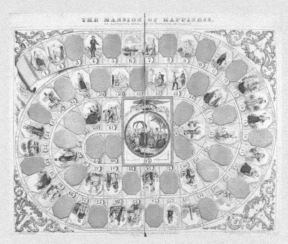

This game was based on the Game of Goose, which is referenced in sixteenth-century literature. Lebrun-Boldetti & Co published an 1872 Italian lithograph with a goose in each corner in a disagreeable scene.

This is one of the first commercial board games made in America (1843), called the Mansion of Happiness. On it you pursue morality, and try to avoid vices.

HEART STREET MAP

❦ MATERIALS ❦

→ Piece of copier paper

→ Scissors

→ Piece of watercolor paper

→ Low-tack tape such as blue painter's tape, cut into ¼-inch (6 mm) strips or narrower

→ Stencil brushes

→ Inkpads

→ Waterproof pen, black, such as a Micron pen

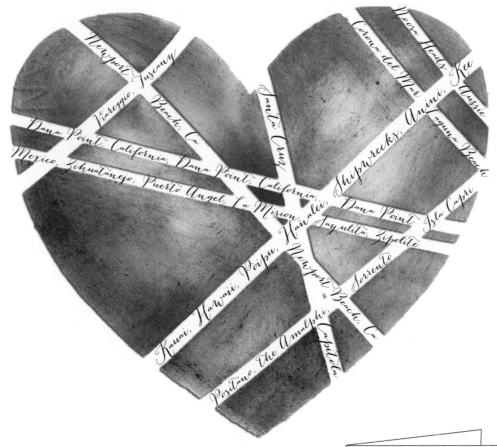

"Your vision will become clear only when you can look into your own heart. Who looks outside, dreams; who looks inside, awakes."

—Carl Jung

This is a map of the streets of your heart. Name them anything you like—after loved ones, loved places, loved books—the choice is yours. The heart above represents a love of the sea and familiar beaches.

This project was done on watercolor paper with a stencil technique called *pochoir*. You can also do this with paints on canvas or board.

Fig. 1

Fig. 2

Fig. 3

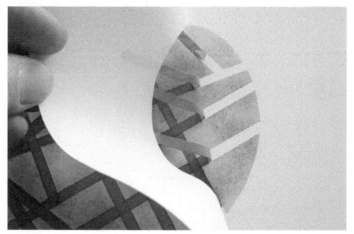

Fig. 4

Fig. 5

1. Fold the copier paper in half and cut out a heart shape. Leave space at the top and the bottom. (Fig. 1)

2. Lay the outline of the heart on the watercolor paper.

3. Place the strips of painter's tape across the heart. Press them lightly so they stick and will be an effective mask, but not so hard that they will tear the paper beneath when you remove them. (Fig. 2)

4. Use your stencil brushes to apply the inks over the top of the streets. Use as many colors as desired. (Fig. 3)

5. Be careful not to brush ink under the edge of the heart cutout paper. Hold the brush vertically to avoid this. (Fig. 4)

6. Remove the tape and paper heart. Add street names with pen. (Fig. 5)

LAB № 36 DETOURS

MATERIALS

→ Resource materials

→ Art paper

→ Pencil

→ Felt-tip pens, such as Microns

→ Colored pens or pencils

"A man's work is nothing but this slow trek to rediscover, through the detours of art, those two or three great and simple images in whose presence his heart first opened."

—Albert Camus

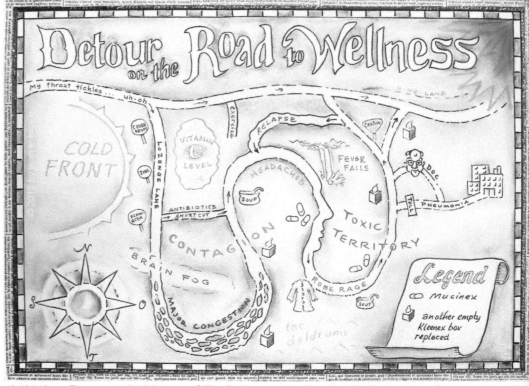

Artist Jean Brown made this map of The Detour on the Road to Wellness when she was sick with a cold. If laughter is the best medicine, this must have worked!

If life is a journey, then a Life Map must include detours from our intended paths. My heart's desire from the time I was small was to write books, and I wanted to write them immediately. The Map of Detours on the opposite page shows the meandering way I took to arrive at my childhood dream. It features lovely stops along the way: moving away to college, having my kids, returning to college for a teaching credential, and many relocations as I juggled teaching, my growing family, and developing my writing skills.

Detours are not necessarily bad: Some are remarkable, unexpected forays into new lands. Some are people and places that open our hearts wider than we thought possible. Others are trials to overcome, one step at a time.

1. Decide on a theme: your creative life, your health, your career ... choose whatever you feel most like exploring.

2. Imagine a direct route to your goal.

3. Now, list the obstacles or delays. Collect resource materials that will help you draw or portray them. You can be literal or figurative.

4. Sketch your starting point on the art paper, adding in a path or roadway that will eventually get to your goal.

5. Place obstacles along the path, with detours leading to and past them.

6. Continue until you have shown the way to your goal. Color as desired and write with the felt-tip pens.

It's a long journey to the writer's life, but it's worth it.

LAB №37 COLLABORATIVE MAP BOX

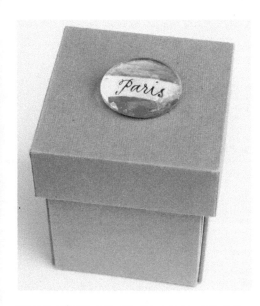

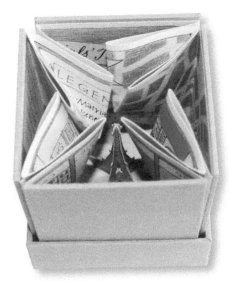

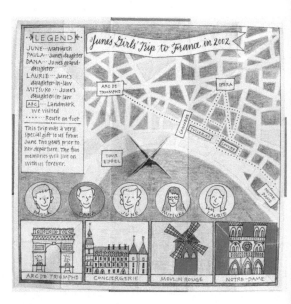

❧ MATERIALS ❧

→ Square sheet of medium-weight paper (for the map)

→ Colored pencils

→ Steel ruler

→ Glue

→ Cutting tool

→ Square piece of cardstock that is one-third the width of the map plus a small bit extra; add overhang width on all four sides (for the lid)

Making maps about shared experiences, or making a map with people you shared those experiences with, can be fun and enlightening. Even though you were at the same place at the same time, it is amazing how different your viewpoints may be. For this project, you can focus on a vacation, or the celebration of one day, or many. Because it is three-dimensional, you can put a treasure inside that commemorates that day.

Artist Mitsuko Baum made this project to commemorate a trip to Paris she took years ago with female relatives. The hostess of the trip was her mother-in-law, June, who has since passed away. She drew caricatures of her fellow travelers, marked their walking route, and added the sights they saw. Baum's beautiful piece will keep this memory alive forever.

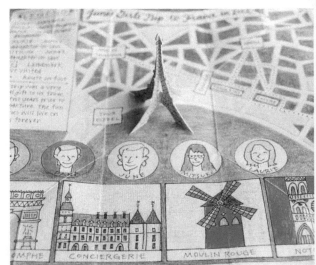

1. Before you score or fold the box, draw the map. Do it yourself or ask those who you shared the event with to add their own comments and drawings. Include routes and a legend that includes all your names and some of the things you did.

2. Add some pictures of your adventure together. You cannot collage on this map or it will not fold properly, so get brave and draw! Even the simplest of maps are enchanting, especially when you make them with someone else.

3. Add color to finalize your map.

4. Measure the map into thirds and score all lines as per the diagram. It is a great idea to try this on a piece of scrap paper before you start in on your map. (Fig. 1)

5. Fold your map on the scored edges on all sides. Do not fold all the way across the diagonal. See the directions on page 46, "Folds and Pop-Ups", for how the folds in the corners go back and forth. This box has an additional fold, so make that one reverse again.

6. Set your map in the box and see if it can fit without touching the folded corners. Glue it in. You can cut out a design from the cardstock and make a small sculpture like Baum did.

7. Cut and score the lid. It should be slightly larger than the box when it is folded up so it will fit over the top. (Fig. 2)

8. Glue small tabs on the corners and attach them to the adjacent lid overhang, then place on top of the box.

9. You can glue cardstock to the sides and bottom to make it stronger.

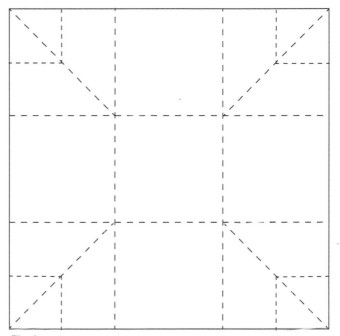

Fig. 1

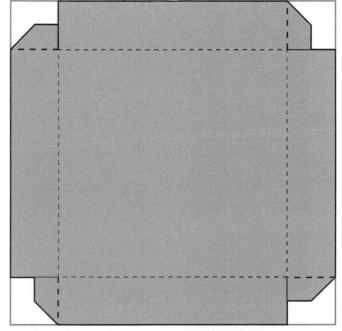

Fig. 2

LAB № 38 MAGICAL PLACES

→ MATERIALS ←

→ Notepad and pencil

→ Paper on which to collage or draw your map

→ Gathered images or drawings

→ HISTORY TIDBIT ←

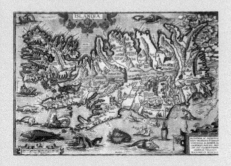

The magical map of Islandia was done by Ortelius in 1603. It is a fairly accurate map of Iceland with an amazing lineup of mythical and legendary creatures he copied from other monster masters of the fifteenth and sixteenth centuries.

Certain places are so special to us that we know a great deal more about them than the average passerby would ever notice. We learn about the special people who live there, the unique features of the land, the depth of its past. When we truly know a place, including its stories and secrets, it becomes magical.

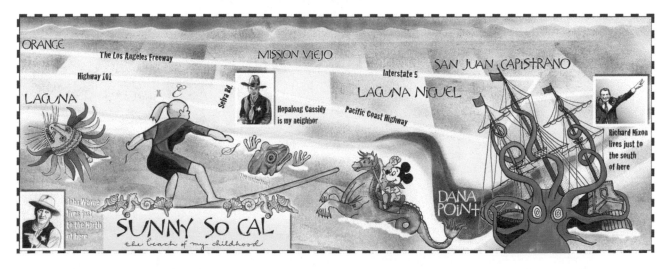

Dana Point (above) is the beach of my childhood in sunny southern California. I spent most of my weekends and summers there for many years. I knew that there was an "undertoad" that would take you away if you weren't careful, and that the place was named for Richard Henry Dana, a nearly blind sailor who might not notice if a giant squid climbed aboard his ship. (See lower right of map.)

Disneyland was nearby and Mickey Mouse would want to ride there on a seahorse. A hippy sea monster swam toward the shores of Laguna Beach, where everyone wore tie-dye and made sand candles. Some famous people resided nearby, and we all lived for sightings of them, which rarely happened.

It was a place where I felt safe and happy and full of imagination.

Omey Island (opposite), a tidal island in Connemara off the coast of Galway in the west of Ireland, made by visual artist Sean Corcoran, who is a passionate and frequent visitor. He did not use recognizable or common place names, but derived his own from observations he made of the island from 2003 to 2009.

From the mainland at Claddaghduff the island is inconspicuous. In fact, you could drive along the coast road and not even realize the island exists in the panoramic view below you. When the sea surrounds the island the atmosphere changes as if everything is at peace and in harmony. Poets, philosophers, writers, and artists have been inspired by this sensation.

Omey is as much a part of the spirit of the community as the people are. This is a place of joy and sorrow, of life and death. Don't be fooled into thinking that time stands still here. Everything is constantly moving and changing, with shifting sands, water, rocks, and skies. This is a magical and mysterious place.

1. Where is your magical place? Sketch it out on your paper.

2. Make a list of its stories and secrets you know.

3. Find symbols, pictures, or drawings that represent those stories and collage or draw them on your map. You can add these to your legend if you like, as shown in the Omey map.

4. Add as many symbols and images as you like until it feels like the magical place you know. The symbols do not have to be obvious. No one else needs to know what they signify. This is your own magical place, after all.

Susan Wade, a high school art instructor from Burnaby Mountain Secondary School in Burnaby, British Columbia, asked her grade 8 students to break down a personal journey and translate it visually, following the instructions in Lab 34: Get Your Game On. She says this about the project: "The finished art becomes a treasured keepsake to look at over and over, [the artist] appreciating that particular event that he or she chose to map out."

"The map project that Ms. Wade created from Jill Berry's idea is one of the best I've ever seen. It was unique, creative, and mostly fun! I hope we get to make more things like this!"

—Nick Shin, age 13

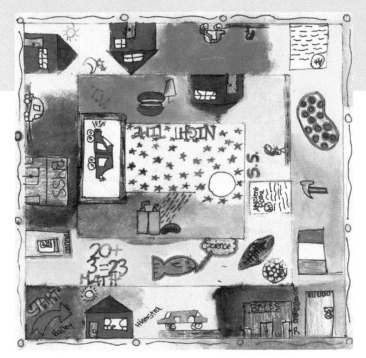

"I enjoyed that we made maps of our student timetable because we put things into art that we usually wouldn't."

—Bailey Heimstra, age 13

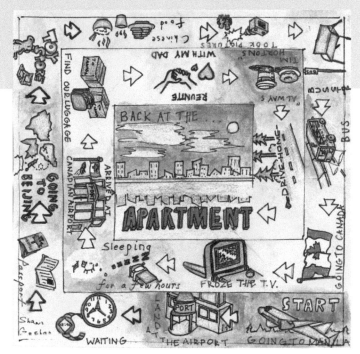

"My experience in making my map was like a roller coaster because I was basing my journey about returning to Canada and there was so much I saw and enjoyed but I had a limited amount of space. But in the end it became a true masterpiece."

—Shawn Gochan, age 13

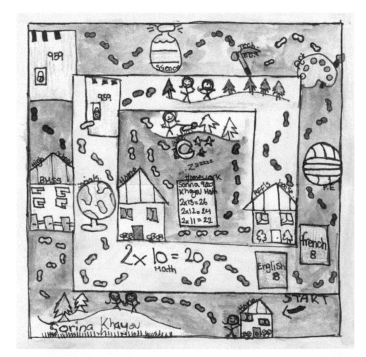

"I enjoyed talking about our grade 8 life. For the maps I enjoyed making basically everything about it. I had so much fun learning about color and using letters as art too! I hope we do it again next year!"

—Sorina Khayou, age 13

UNIT № 06

CARTOGRAPHIC PROJECTS

This section is about creating with maps that are already printed. In some cases the maps are from brochures; others are made from tossed-off children's toys, and still others from the stacks of printed maps we cart home from vacations and cannot seem to part with.

In these pages you will find books and sculptures, jewelry, mail art, and collage, all simple and exciting projects that put to use those maps you've been saving.

Palace Girl (opposite) was made and inspired by a map from a trip years ago to Schönbrunn Palace in Vienna, Austria. The main lobby area looked just like a girl, with the adjoining side rooms becoming her hair. The design went from there, using mostly that particular map and adding a few others. The ribbon neatline was added at the very end.

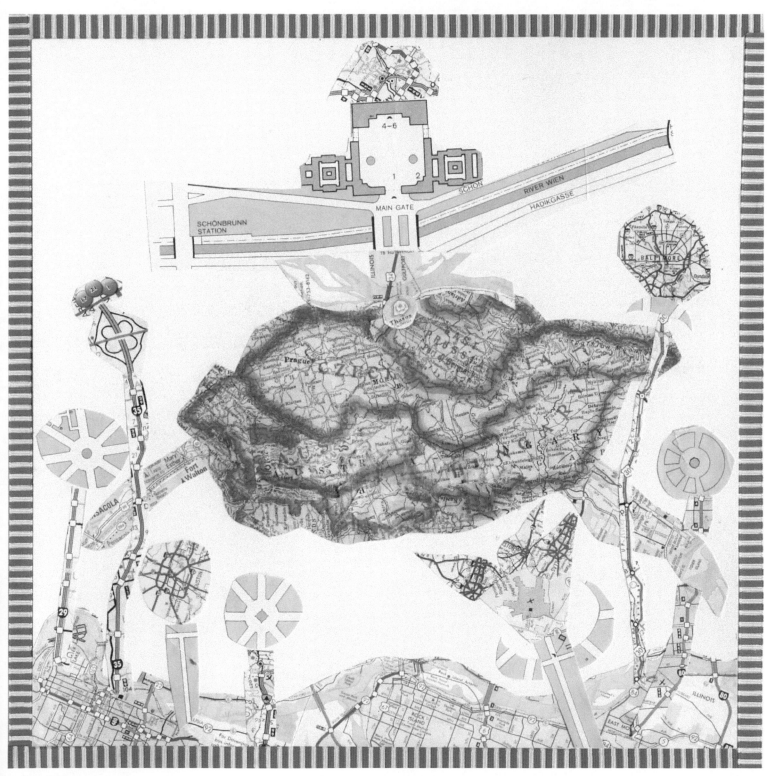

Palace Girl

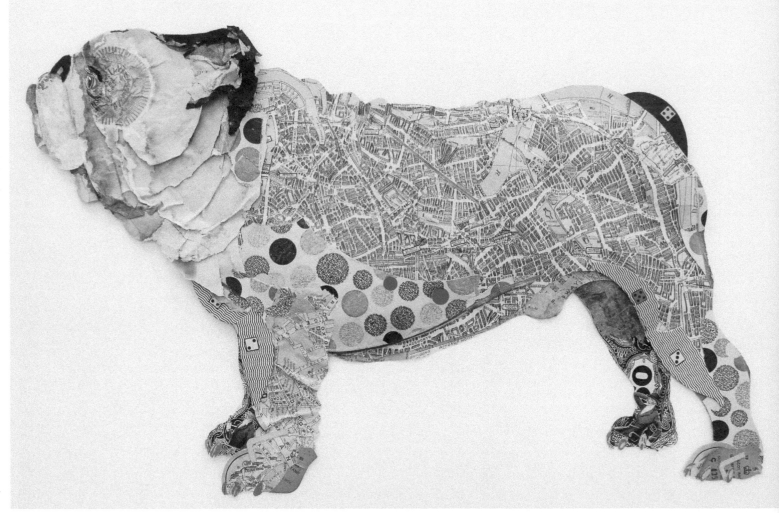

Flat-nosed George

Peter Clark "paints" with found papers. Some are colored, patterned, or textured. Some surfaces are worn with age or use. Many are covered in print. He uses the variety of color and print density to create depth and a sense of relief. He uses lines from old maps or manuscripts to create substance and movement. His creations are innovative and humorous uses of the marked page.

Clark began drawing from nature walks as a boy in northern England. He studied art and design in college and later held many art-related jobs before he began making collage.

INSPIRATION

When a street drawing morphed into part collage, Clark began—for no apparent reason—to add text from his computer to a compilation, and it became a generic dog. The positive feedback helped birth his new career. At first he only made dogs, but then he began exploring other beasts and then garments. He was intrigued to try a paper version of clothing when several artists, all of them textile designers, were planning a show. The good reception he got from his creations spurred him to continue his quest for vintage paper scraps to bring to life.

Clark is adamant about creating things by hand from actual materials rather than digitally. He believes that old paper has charisma and integrity that cannot be replicated by computer. He looks for well-used paper that was a part of people's everyday lives rather than valuable historical documents. Part of the fun of creating these pieces is the thrill of the search as he and his wife and soul mate, Karen Nicol—a textile artist—travel to far-reaching places to find just the right scraps.

Clark usually starts with a word or phrase that strikes him somehow. He studies and thinks about it to find the best way to illustrate the concept, aiming always for humor. Then come sketches, followed by drawings on tracing paper so he can see the papers he auditions through it.

The difficult part comes next: finding exactly the right papers for the collage among his vast collection of maps, postage stamps, postcards, cigarette packs, matchboxes, charts, and all kinds of other paper. This process can be immediate or very slow. Taking breaks to keep his creativity flowing helps, and bouncing ideas around and brainstorming with Karen keeps things fresh. He also takes long, aimless walks around London, looking carefully at people, color, and textures—noticing every detail—to keep his creative spirit moving.

Daddy's Girl

Timi

LAB № 40 PERSONIFY A PLACE

✦ MATERIALS ✦

→ Image of a special person

→ Art paper

→ Ink pen, such as a Micro, in size 08 (0.55 mm)

→ Coloring pens or pencils

Artist Laurie Mike made this piece, The Virgin of San Miguel, *from maps of that city, polymer clay, and various charms and beads.*

Maps have been made into the shapes of people and animals for hundreds of years and for many reasons—most of them funny. The image at the right is a satirical map of Italy from *Geographical Fun, or Humorous Outlines of Various Countries*, published by Hodder and Stoughton in 1869. The author, William Harvey, writing under the pseudonym Aleph, created a series of twelve maps showing countries as people in the tradition of English caricaturists. The idea behind the maps was taken from sketches drawn by a fifteen-year-old girl trying to entertain her bedridden brother.

Aleph's Italy

Harvey states in the introduction: "It is believed that illustrations of Geography may be rendered educational, and prove of service to young scholars who commonly think Globes and Maps but wearisome aids to knowledge." The maps were designed to amuse children and teach some basic geographical concepts.

INSTRUCTIONS

Fig. 1

Fig. 2

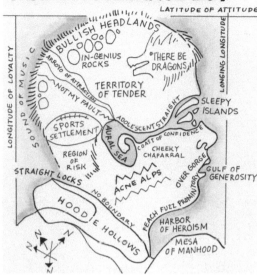

MAP OF A TEENAGE BOY

Fig. 3

1. Get a photo of someone you want to map. (Fig. 1)

2. Trace or freehand draw your person's shape. (Fig. 2)

3. Make a list of the distinctive features of your person and combine them with map terms to make names for the places on your map.

4. Add color and a title. (Fig.3)

TAKE IT FURTHER

You can make maps of people or animals you know using their most distinctive features as the basis for the geography of the map. Here, artist Theresa Hall made two maps with animals in mind.

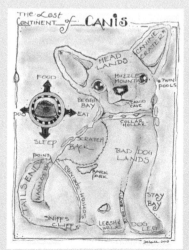

The Lost Continent of Canis

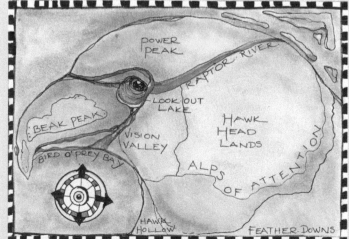

Feather Downs

PUZZLED AGAIN

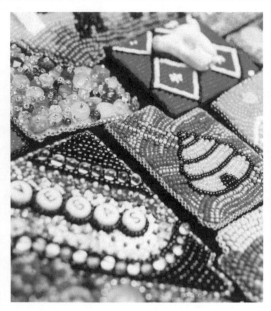

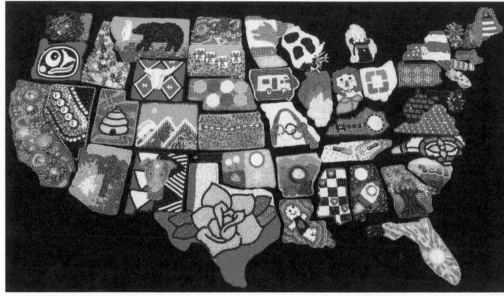

MATERIALS

→ A map puzzle

→ Decorated paper

→ Paint, markers, or other decorative items

→ Scissors

→ Gesso

Puzzles are a staple in many households, and map puzzles are a quintessential example of what we all might have in the bottom of a toy bin. They often lose their pieces, but it takes a while to cull them from the playroom because we like them so much. You can use parts of map puzzles to make jewelry, decorations, and elements of mixed-media and collage projects. You can also use them to make real art.

In the project above, artist Laurie Marcum beaded each state using a state map puzzle that had been in her family for ages and was losing its utility. She outlined the states on the map, then using bead embroidery, she fashioned designs for each piece, adding a silver stamped bead to each to signify the capitol of each state, and to unify them with one element.

Each one of her states has a story. Utah is the "beehive" state and has beautiful rock formations and a rich railroad history. Just north of there, Idaho is nicknamed the "Gem State," because nearly every known type of gemstone has been found there. Laurie researched facts and stories about each state, adding her own experiences in the states she had been to. The result was a country full of glittering stories.

1. Find an old map puzzle that may be missing some pieces. Place the part you want to work with on a decorated piece of paper and trace the outline. Here the outer frame pieces are used to get the whole shape of Africa. (Fig. 1)

2. Cut out the paper you just outlined. Paint, draw on, or otherwise decorate it as you like. Africa, as seen here, was distressed with inks and matte medium. (Fig. 2)

3. Take one of the pieces of the puzzle and paint it with gesso. Add marks or symbols that have to do with that place, then paint it. Ethiopia was added here, because of its rich alphabet, food, and relationship to the artist. Add the puzzle piece back into the map and adhere.

Fig. 1

Fig. 2

❧ HISTORY TIDBIT ❧

While map table games were essentially toys, dissected maps would sometimes be used in the schoolroom. The educational uses of the puzzles were stressed in advertisements. The text on the box containing Colton's Geographic Combination Map of the United States in this exhibit reads in part: "The design of the Publishers has been to furnish an agreeable and attractive method of imparting to the young a knowledge of Geography, and of blending amusement with instruction ...

"The act of combining these parts exercises and amuses the mental faculties; and the study of Geography thus made attractive is rapid and permanent in its results; and more knowledge of the subject is acquired in one hour spent in this intellectual amusement than in a month of hard book-study."

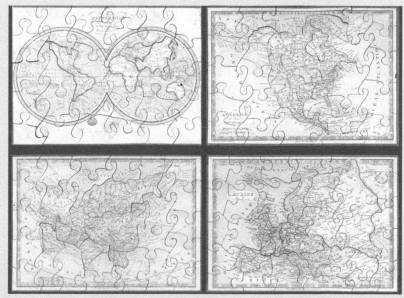

Jigsaw puzzle atlas published by Auguste Logerot in England, c. 1850

LAB № 42 CARTOGRAPHIC JEWELRY

Cartographic jewelry is a fun way to show off your love of maps. You can upcycle your out-of-date atlas or maps, or use maps from trips to make keepsake treasures to wear.

→ Pencil

→ Paper

→ Craft knife

→ Atlas pages or maps

→ White glue

→ Small paintbrush

→ Pliers

MINI MAP EARRINGS

→ Wooden rectangle letter tile from craft store

→ Copper acrylic paint

→ 2 copper headpins

→ 4 beads

→ 2 copper ear wires

MAP BEAD NECKLACE

→ Craft lollipop sticks

→ Skewers

→ Beading string and needle

→ Glass and metal beads

→ Medallion (I used a button and cut off the back)

→ Necklace findings

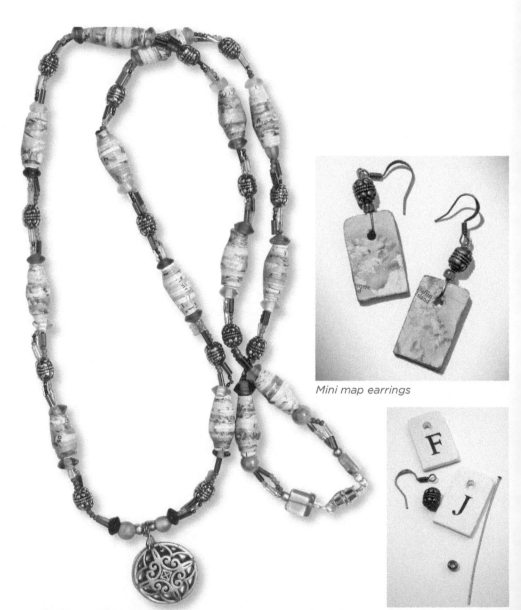

Map bead necklace

Mini map earrings

Materials for earrings

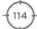

MINI MAP EARRINGS INSTRUCTIONS

1. Trace the wooden rectangle letter tile onto a plain piece of paper about twice its size. Cut out the rectangle, but make it a bit larger than the outline. Then cut a small frame around it. This little window will help you audition sections of the map for your earrings. I am drawn toward complex coastlines and contrasting colors. (Fig. 1)

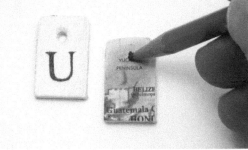

Fig. 1

Fig. 2

2. Select two pieces that complement each other and trace them lightly with your frame. Cut them out with the craft knife. Carefully erase the pencil marks.

3. Glue the map rectangles over the letter on the craft tile. Trim away the excess paper with the craft knife. With the point of your pencil, poke the area where the hole is. Press the excess paper into the hole. (Fig. 2)

4. Paint over the map with glue, letting each layer dry. Be sure to glue sparingly inside the hole. Repeat several times.

5. Paint the backs and sides of the rectangle with copper paint and let dry.

6. Thread the copper headpins through the holes, pulling the ends of the wire even above the wooden piece. Twist the wooden piece while holding the wire securely with pliers. Do not overtwist.

7. Thread the beads over the twist and loop on the ear wire.

MAP BEAD NECKLACE INSTRUCTIONS

1. Cut 10-inch-long (25.4 cm) skinny triangular pieces of your map for the beads. The wide end will be the length of the bead, about three-quarters of an inch (1.9 cm). Mark the triangles lightly with pencil and cut with the craft knife. Repeat for the number of desired beads, and create several extra in case of waste. (Fig. 3)

2. Lay the lollipop stick along the base of the first triangle. Roll as securely as you can toward the tip until you have gone around the stick once completely. Now paint glue on the inside of your triangle as you roll. Roll the stick in a straight motion so the triangle is centered. (Fig. 4)

3. Gently pull the bead off the stick and place it on a skewer. Paint the surface of the bead with glue until well layered, letting the glue dry between coats.

4. String the various beads, arranging them in the way you'd like. Attach necklace findings to the ends with pliers.

Fig. 3

Fig. 4

✤ MATERIALS ✤

→ Cereal boxes (cut into rectangles)

→ Scissors

→ Various heavyweight papers

→ Maps

→ Ephemera of all kinds, such as postage stamps, postcards, and envelopes

→ Decorative tapes

→ Strong tape

→ Glue

→ Acrylic paints and paintbrushes

→ Sharpie Paint Pen in white

→ Waterproof pen, such as a Micron

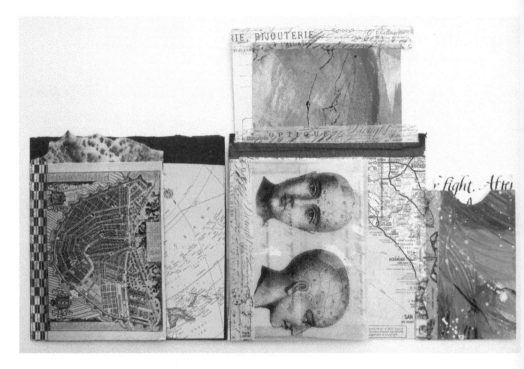

The Age of Discovery, also known as the Age of Exploration, was a period starting in the early fifteenth century and continuing to the seventeenth century during which Europeans explored the world by sea in search of new lands, peoples, goods, and trade routes. This period is also considered the great or classic period of piracy. Pirates are by definition the bad guys of the sea: They sacked other ships and stole their goods. Captains often threw their maps into the water rather than hand them over to pirates, and sometimes the ships sank to the ocean floor with all the ship's bounty.

This project was inspired by Juliana Coles, who is herself a pirate known as Captain Morgan La Fey. The journal is a series of maps, words, drawings, and upcycled materials that come together as a record of a discovery of an underwater map, other booty under the sea, and anything else an explorer/pirate might want to record while sailing the seven seas sacking ships. The voyages are imagined; you can go anywhere you like in this journal.

INSTRUCTIONS

1. Think about your journal first. What is your pirate name? What would you like to discover in your underwater map? Who are your comrades? What adventures do you have?

2. Gather your materials. (Fig. 1)

3. Pick your cover first, created by breaking down the cereal boxes and cutting them into rectangles. Compose your pages out of the papers in your stash to fit inside it.

4. Tape the pages together one at a time, and then tape them into the cover. Washi tape works great for the pages inside, but you should tape the spine (the space between two cover papers) with stronger tape.

5. Collage on your pages with glue, color them, paint them in white and black, and journal on them as you think about what your explorer might do.

JULIANA COLES' JOURNAL

Thems that know me know I be pirate. Aye, me mum be the late, great buccaneer Josephine Juana La Loca! I could not tell me tale without including the brethren: Falcon La Grange, Pinky La Rouge, QM Jessie Starling, Fearless Iron Gem, Alvida Viper. Had I not these brave sailors and the School of the Sea, I would never have discovered the underwater map through its trail of salty tears . . .

Shiver me timbers! Below the surface, among the flotsam and jetsam of the tide pool of self-discovery, lies the underwater map of soulful and wondrous secrets! So chart yer course, raise the colours, and sink into being, for what may seem treacherous be the safe harbor. What thar be left to tell of the ancient mariner and the underwater map? Dead men tell no tales. It be left to me to make it up as I go along . . . But then, I'm a pirate.

Sincerely, Captain Morgan La Fey of the H.M.S. *Black Swan*

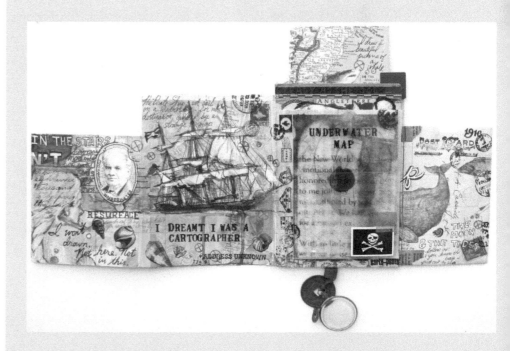

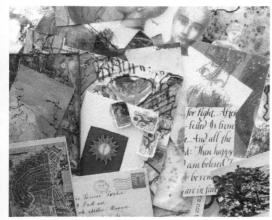

Fig. 1

✣ MATERIALS ✣

→ Postcard featuring a map or a map and cardboard

→ Glue or glue stick

→ Map of where you live

→ Photo of you

→ Colored pencils or markers

In the Age of Discovery, European explorers roamed the earth trying to find new lands to claim for their kings and queens. This exploration allowed the global mapping of the world and connected people and lands that had previously been unknown to each other, resulting in a new worldview.

What took many centuries to start can now be accomplished in one push of a button. Social media connects us to the rest of the world immediately. In this case, I posted a call for Cartographic Correspondence, which translates to "send me a postcard that has to do with maps." My request was reposted by many people, and in the subsequent months I received postcards from all over the globe.

For this project you are going to refashion a postcard with maps of your town, your heart, or any other map you have lying around.

This is a great project for a class or group, especially if you set it up as an exchange with another class or group.

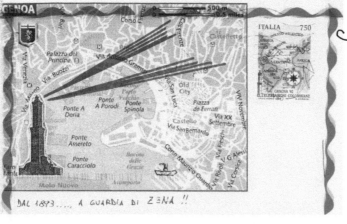

BAL 1893..., A GUARDIA DI ZENA !!

1. If you are using a map and cardboard, adhere the map to the board and trim the excess.

2. Onto your postcard, glue a map of where you live and a photo of you.

3. Write some pertinent information about where you are in your life.

4. Send it to a friend.

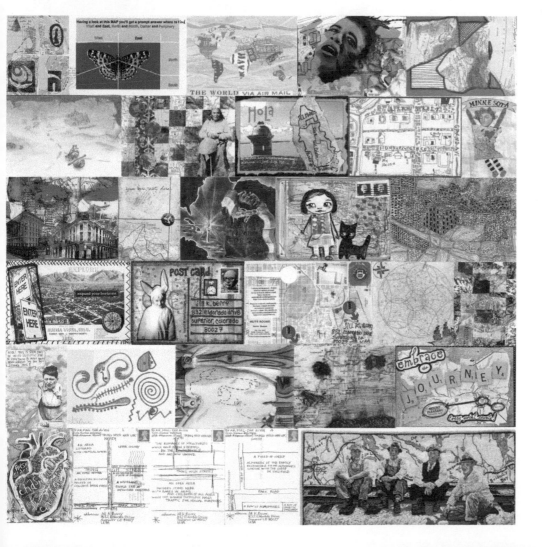

❧ MATERIALS ❧

→ A copy of a simple map

→ Heavy paper such as Tyvek

→ 1 piece heavy-weight paper

→ Stapler

→ Pencil or dark pen

→ Cutting tool, such as a craft knife or scalpel

→ Ruler

→ Dark colored paper

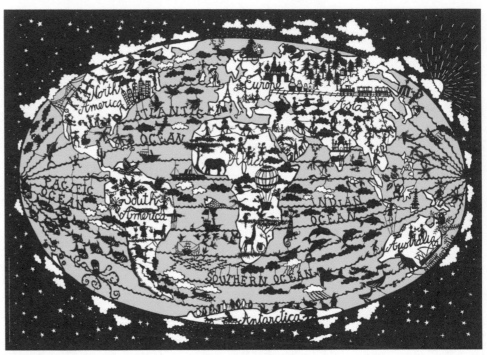

This world map shows flora and fauna from around the globe, as well as enchanting sailing ships.

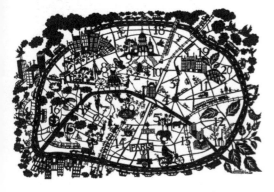

This cut paper map shows all of the arrondissements (districts) and attractions of Paris, as well as some of the quirky sides of Parisian life.

Paper-cutting as an art form is a centuries-old tradition. The oldest known piece survives from sixth-century China. In Mexico, this art is called *papel picado,* while in Japan it is called *kirie.* Paper-cut art is popular in Israel, India, Indonesia, China, and many other countries.

Famille Summerbelle, a duo from France and England, cuts whimsical and meticulously detailed maps. Creators Simon Summerscales and Julie Marabelle say the inspiration for Famille Summerbelle came from the combination of family life experiences and a love of design. Famille Summerbelle is perfectly split between France and the United Kingdom: They love both cultures, and the dual base provides them with creative inspiration.

These maps were imagined and designed by Marabelle, whose background is a mix of fine art (which she studied in Paris) and theater set design (which she studied at St. Martin's in London). Summerscales, who has a background in advertising, is Famille Summerbelle's managing director.

Fig. 1

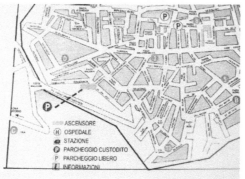

Fig. 2

Fig. 3

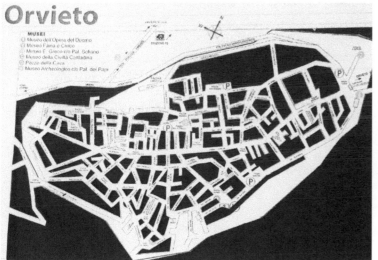

Fig. 4

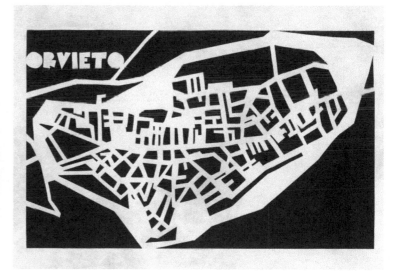

Fig. 5

1. Stack the map on top of the Tyvek paper and heavyweight paper. Staple the layers together. You will cut all three layers at once, which will give you two copies of the cut map when finished. (Fig. 1)

2. Draw borders and lines where you want to stop cutting so you don't accidently cut a support piece. (Fig. 2)

3. Cut out areas that will best show off the map, using a sharp tool and a ruler whenever possible. You do not need to include every single detail or street. Combine small areas. (Fig. 3)

4. Slip a piece of dark paper under the map once in a while to see how it looks. (Fig. 4)

5. When you are done, pull the staples out and trim the edges if needed. Then frame! (Fig. 5)

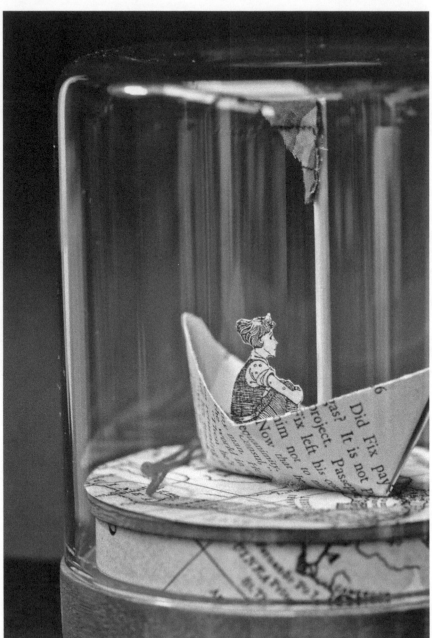

Little Lucy All at Sea

Anne Marie Gee spent her childhood in an idyllic seaside town in Albany, on the south coast of Western Australia. She loves the art of storytelling through maps, pictures, the printed page, and spoken stories. She has collected old books and maps since she was a teenager, pouring over the sepia pages, breathing in that gorgeous musty smell of old bookstores and packing boxes. Recently, Gee started using started vintage books and papers in her artwork. She began with simple paper, which evolved to include vintage characters, text, and maps from her vast collection.

Gee's paper sculptures are all three-dimensional works that bring the flat world of the printed page to life. No longer are adventures stuck between the pages of maps folded with dusty creases, closed and stored on bookshelves and in boxes. They have been reborn, sailing on to new destinations, inspiring and guiding the journeys of new generations.

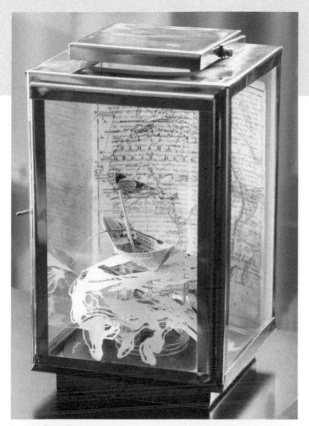

Look Out George

George's jolly boat is folded from vintage paper from an 1887 children's book and the looming wave is hand cut. George originates from the 1912 Boys' Book of Sports.

LUCY AND GEORGE—RED THREAD SERIES

Little Lucy All at Sea originates from *The Favourite Wonder Book* circa 1938. Lucy is set adrift on a vintage map of Africa. Her little boat is folded from one-hundred-year-old storybook paper. Lucy is hungry for adventure, but calm in the knowledge that a map will serve her well.

In *Look Out George*, George used his map to make his way downstream but found himself in a precarious predicament.

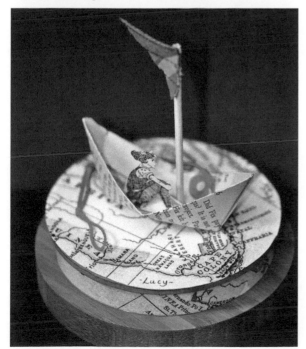

Little Lucy All at Sea

INSPIRED BY ARTISTS

Imagine being surrounded by the people you admire most: artists, musicians, storytellers, relatives, and historians. You gather them in a village, and they teach you everything you want to learn. In this case, artists inhabit the village, and after we construct a place for them to reside, we will go about learning how each of them might fashion a map.

The artists included here are some who have influenced us throughout our lives by their art, writing, illustrations, sculpture, printmaking, activist natures, painting, and poetry. Each one has contributed to the artistic tapestry of our lives and offers many inspirations for this creative journey.

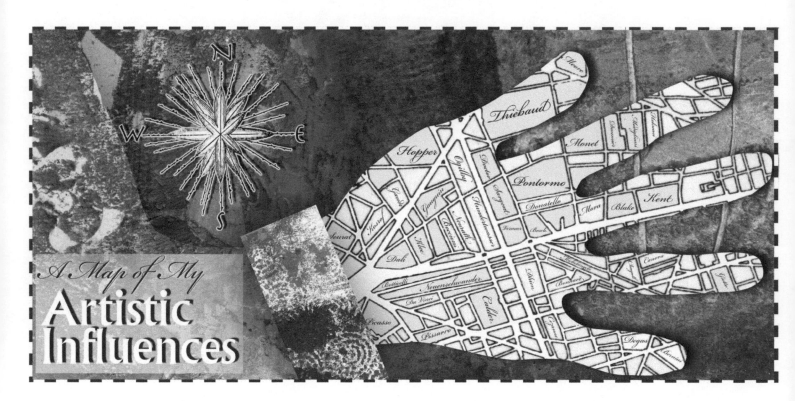

In the 1920s and '30s, Paris was filled with artists. This made a vintage map of Paris the perfect inspiration for this project: a personal, fantasy neighborhood containing influential artists, teachers, and creative thinkers.

In this neighborhood, each house contains someone special, each one of your choosing. You decide who you want to rub elbows with at the local café or invite for dinner. They can be alive or not, real or fictional characters filling the blocks with your own idea of utopian neighbors.

❧ MATERIALS ❧

→ A copy of this map, or find your own

→ Scanner

→ Computer

→ Photo-imaging software

→ Colored and textured papers for collage, or scans of them for a digital collage

→ Markers or pencils

Fig. 1

1. Copy this map, or scan it into an imaging program. (Fig. 1)

2. Fill in the folks of your choosing for your fantasy neighborhood. They can be famous or not—it is your fantasy!

3. Add collage and textures using imaging software, or by hand. (Fig. 2)

4. Add a title block, neatlines, and a compass rose if you like!

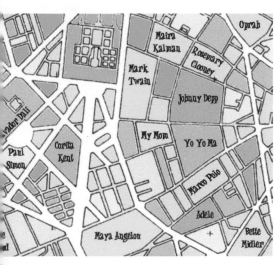

Fig. 2

• MATERIALS •

→ Wire cutters

→ Upcycled construction wire

→ Craft wires

→ Needle-nose pliers

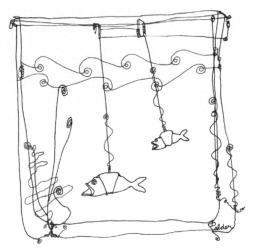

Line drawing of Calder's goldfish.

American artist Alexander Calder (1898–1976) was born into a long line of creative people. He was prolific, creating whimsical and delightful sculpture in every medium: paintings, illustrations, jewelry, housewares, and toys. Calder used up-cycled materials long before it was trendy to fashion his wire circus performers, yarn creatures, and metal dancers. His studio was a mess, but his art is clean, expressive, and balanced.

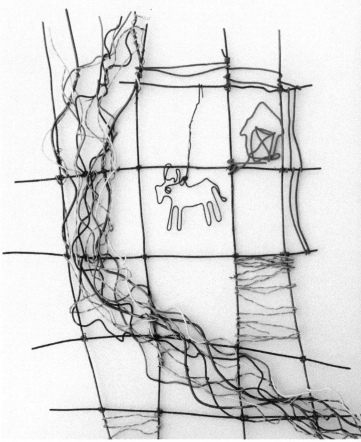

Wire map inspired by Calder

This map is made out of upcycled construction cables that, when sliced open, contain lots of little colored wires inside. There were many greens and blues, so it seemed a river was in order. Calder's 1929 piece *Goldfish Bowl* was made out of wire. That piece was the inspiration for a field and a cow. The fields, river, farm, and paddocks were made with the playful attitude of Calder and the fun of imagining farmland from the sky.

INSTRUCTIONS

1. Cut open the plastic tube around the construction wire. Pull out the different colors you wish to use. (Fig. 1)

2. Decide on your map design. Simplicity is best here; don't worry about being overly representational.

3. Lay out a grid with the heaviest-weight construction wire. Fasten that with craft wire. (Fig. 2)

4. Using the pliers, fashion the objects or beings that will occupy your map. (Fig. 3)

5. Attach the objects to your grid with the smaller-gauge craft wire.

6. Weave in waterways and other mappish elements.

Fig. 1

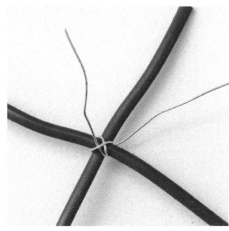

Fig. 2

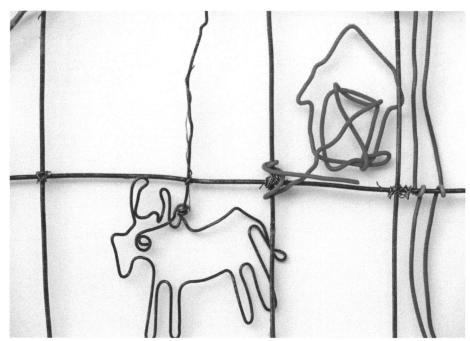

Fig. 3

"The underlying sense of form in my work has been the system of the Universe, or part thereof. For that is a rather large model to work from."

—Alexander Calder

GUSTAV KLIMT:
A VILLAGE FOR ARTISTS

❖ MATERIALS ❖

→ Scissors

→ Colored papers: black, white, gold, green, and blue

→ Glue

→ Paints: blue, white, red, and gray

→ Sponges

→ Gold paint in a squeeze bottle

→ Papers of all kinds

→ Various printed papers

→ Markers: green and black

→ Black fine-tip marker

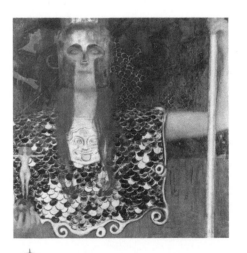

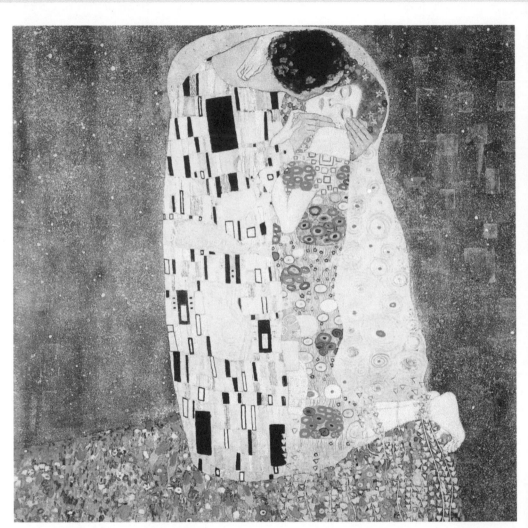

Gustav Klimt (Viennese, 1862–1918) was an artist who created paintings and mosaics. This is his most famous painting, *The Kiss* (above), done in 1907. It is a very romantic painting for a guy who was forty-five and still lived with his mother!

Little is known about Klimt personally because he was a very private man and rarely spoke in public. His talent was enormous and he worked at improving his skills every day of his life. He was also one of the founding members and president of the Vienna Secession, which was a group that declared no manifesto and included diverse genres

of painters. The group's symbol was Pallas Athena, the Greek goddess of wisdom, courage, inspiration, justice, and the arts. He painted this picture of her in 1898. (Opposite, far left)

Secession artists were concerned, above all else, with exploring the possibilities of art in new and nontraditional ways. They accomplished this not only with their own experiments, but they also strongly encouraged young, experimental, and foreign artists by publishing and exhibiting their work in Vienna.

The composition of *The Kiss* could be a village where all these young artists might live. The village is surrounded by water, flowers, gardens, and lots of little studios to work in, and fits with the shapes of these two lovers. The geometric shapes of the man's cloak are the houses and studios, the gentle curve of the woman becomes the river, and the background becomes water that replaces the night sky.

Klimt was excessive in his paintings; they were often covered in many layers of paint and adorned with gold. This is a great opportunity to try being over-the-top artistically speaking. Go for it!

INSTRUCTIONS

1. Cut out the gold piece that you want to represent the village, the green piece that represents the garden, and the blue that is the river. Compose them on top of the black background and glue down.

2. Add some blue paint with a sponge on the black background, lightly tapping the color on the paper. Let it dry, then add dabs of gold paint from the squeeze bottle.

3. Divide the village side with wavy lines. Fill in the areas between the lines with rectangles that are black, white, gray, and gold. Use papers, markers, and paints to do this.

4. Add flowers and leaves with the marker on the green garden.

5. Draw circular groups of flowers on the white paper. Cut them out in a circular shape and glue them along the river. Cut circles of decorative paper to make trees and flowers.

6. Make spirals, circles, and long branches of leaves with the gold paint. Do this at the end because it takes longer to dry and you don't want to smear your village. (Left)

LAB № 49 MY MONDRIAN

MATERIALS

→ A map of the area that you'd like to represent

→ Art paper, such as Arches Text Wove

→ Pencil

→ Fine-point marker in black

→ Acrylic paint in black, red, yellow, and blue

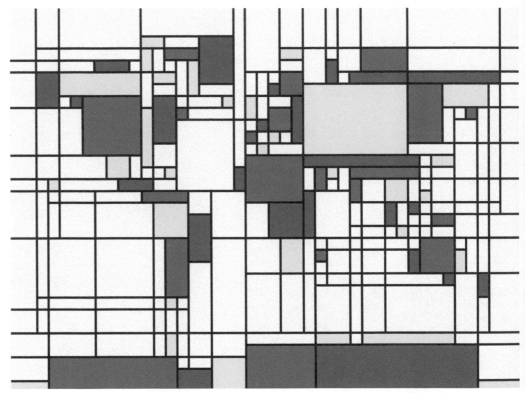

Abstract Map of the World *canvas art print inspired by Dutch painter Piet Mondrian by British artist Michael Tompsett, artpause.com*

"Nature . . . puts me, as with any painter, in an emotional state so that an urge comes about to make something, but I want to come as close as possible to the truth and abstract everything from that . . ."

—Piet Mondrian

Piet Mondrian was a Dutch painter who lived from 1872 to 1944, first residing in Europe and then later Manhattan. He strove for spiritual harmony and order, and believed that pure abstraction and simplicity of form were the keys. Black lines, off-white boxes, and spare use of primary colors are the recognizable elements of Mondrian's style.

When setting out to make a Mondrian-style map, the simplicity of design seems straightforward to execute. It took many versions, however, to get a balance and harmony reminiscent of Mondrian. First, it is important to recognize that white and black (lines and blocks) are dominant in the piece. Next, use a balanced proportion of smaller blocks with larger ones, and include double parallel lines in the form. Last, count the number of blue, yellow, and red blocks to set the proportions so that the map has the quality of a typical Mondrian. Not so easy while attempting to represent the many countries on the continent of Africa!

INSTRUCTIONS

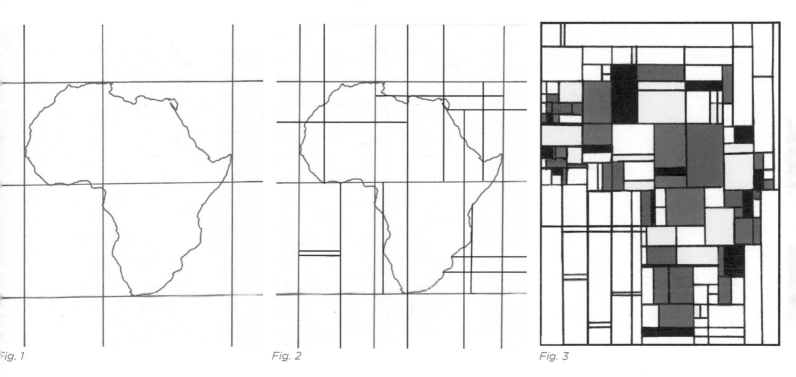

Fig. 1

Fig. 2

Fig. 3

1. Trace the outline of your original map onto art paper with pencil.

2. Using the black marker, make vertical lines at the outer edges of your mapped area, all the way off the page, at the top and bottom.

3. Make horizontal lines at the outer edges of your mapped area. Continue them outward to the edges of the page. (Fig. 1)

4. Continue making lines to close in on the shape, adding more vertical and horizontal lines, following the contours of your land. Try to keep a variety of box sizes and maintain them mostly as rectangles. (Fig. 2)

5. About half of the boxes will remain white (or off-white). The rest will be roughly equally split between black, red, yellow, and blue. Paint them carefully. Though boxes that touch can be the same color, try not to clump any one color too much. Look for balance.

6. Add double parallel lines in the white space. (Fig. 3)

LUCKY EARTH

WITH CORITA KENT

❖ MATERIALS ❖

→ Acrylic paints

→ Paintbrush

→ Paper

→ Palette surface for paint

→ Small craft foam roller

"Don't belittle yourself.
Be BIG yourself."

—Corita Kent

American Corita Kent (1918–1986), also known as Sister Mary Corita, gained international fame for her artwork with its messages of love and peace, which was particularly popular during the social upheavals of the 1960s and 1970s. Our mother had her work hanging all over the house at that time, and it struck a chord with both of us.

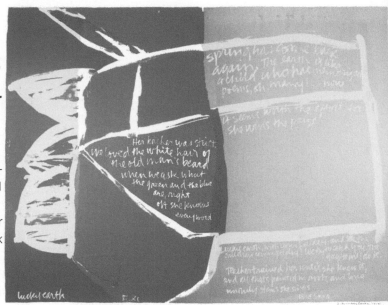

The serigraphs Kent created combined graphic art, typography (sometimes backwards), music lyrics, social commentary, and literature to form her unique style. Kent's art reflects her spirituality and exploration of color, lines, and poetry, and how they all combine. Her work is joyful, simple, and full of curiosity. You have to closely examine her art to find what she is trying to say.

This piece (above) is called *Lucky Earth*. It is a serigraph done in 1963 and includes words by poet Rainer Maria Rilke.

Kent's work was mostly done on a printing press, but there are ways to imitate that artistic style. On page 125 the art was made by cutting colored paper into the shapes she liked to use in her work. The project on this page was done with a craft foam roller.

Fig. 1

Fig. 2

Fig. 3

1. Paint the sky with your paintbrush and then use your fingers to make some shapes that resemble mountains. (Fig. 1)

2. Put several colors on the palette. Use the roller to lift the colors and roll them onto the paper. Work in dryer layers to get textures to show through, or wet layers to make big solid areas of color. (Fig. 2)

3. Continue painting fields, ponds, and other shapes with the roller.

4. When the areas are dry, overpaint white roads between the fields. (Fig. 3)

5. Add text by hand, stencil, or computer. (Fig. 4)

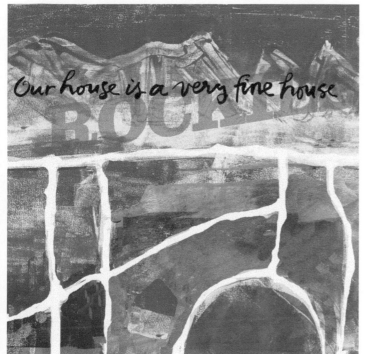

Fig. 4

"Spring has come back again. The earth is like a child who has memorized poems, oh many! . . . now it seems worth the effort for she wins the prize. Her teacher was strict. We loved the white hair of the old man's beard when we asked what the green and the blue are, right off she knows every word. Lucky earth, with your holiday, and all the children coming to play! We tried to catch you. The gayest will do it. Teacher trained her until she knew it, and all that's printed in roots and long unruly stems she sings in a song."

—*Sonnets to Orpheus*, Part 1, No. 21

❖ MATERIALS ❖

→ Map of Barcelona or place of your choice

→ Tracing paper

→ Soft pencil

→ Waterproof pens, such as Microns

→ Watercolors

→ Salt

"You must always plant your feet firmly on the ground if you want to jump into the air. The fact that I come down to Earth from time to time makes it possible to jump all the higher."

—Joan Miró

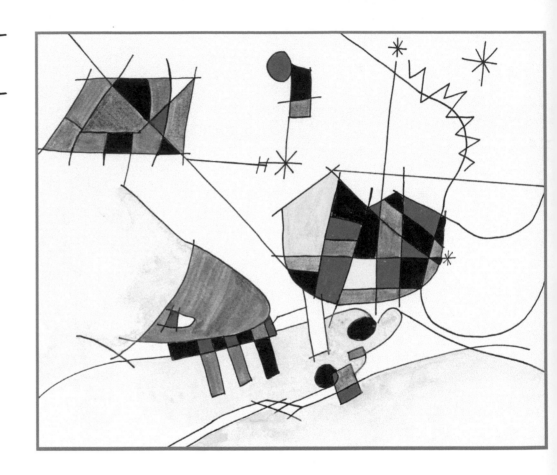

The Spanish artist Joan Miró (1920–1983) was a painter, sculptor, and ceramist. Throughout his life, Miró's goal for his art was to be able to make the painting into a poem while balancing the compositions. He used a technique called "automatic drawing" where the hand is allowed to randomly wander across the page to reveal something from the subconscious, eventually creating his playful vocabulary of symbols and a visual journey. Miró worked in many styles, from fairly realistic to cartoony and abstract. The latter style lends itself to a map. Miró was born in Barcelona, so for this project I will use his hometown. You, of course, may use any town you like.

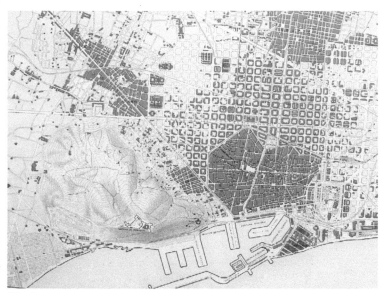

Fig. 1

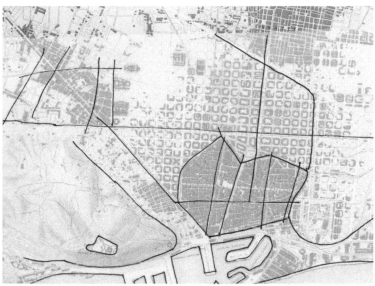

Fig. 2

1. Print out a map of Barcelona. (Fig. 1)

2. On a piece of tracing paper, trace areas and streets on the map that you would like to use. (Fig. 2) Keep in mind the wandering style of Miró.

3. Transfer the map to watercolor paper (the same way you did on page 21).

4. With a black waterproof pen, ink in Miró's shapes over the basic guidelines you transferred. (Fig. 3) Add decorative elements a lá Miró, such as a jagged line and simple stars.

5. Using red, blue, and some bits of orange and green, color in the spaces you made.

6. Add a small area or two of watercolor with salt for texture. Paint with watercolor and while it is wet sprinkle salt on some areas. When the paint is dry, wipe off the salt. (Far left)

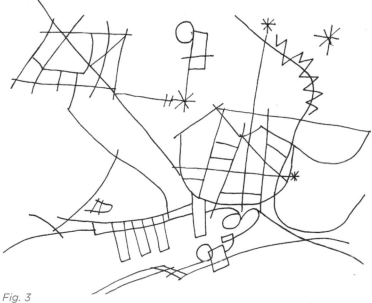

Fig. 3

MATERIALS

→ Materials by an inspirational artist/illustrator

→ Notepaper and pencil

→ Art paper

→ Pen

"My dream is to walk around the world. A smallish backpack, all essentials neatly in place. A camera. A notebook. A traveling paint set. A hat. Good shoes. A nice pleated (green?) skirt for the occasional seaside hotel afternoon dance."

—Maira Kalman, *The Principles of Uncertainty*

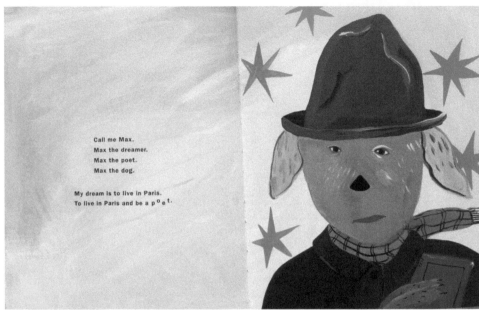

Call me Max.
Max the dreamer.
Max the poet.
Max the dog.

My dream is to live in Paris.
To live in Paris and be a p o e t.

Maira Kalman is an American illustrator, author, artist, and designer. Born in 1949 in Tel Aviv, Kalman came to New York City with her family at the age of four and still lives and works in Manhattan. Kalman writes and illustrates books for adults and children and articles for *The New Yorker* magazine with great wit, wisdom, hilarity, and a bit of history thrown in the mix.

Max is a beloved character in Kalman's stories. He is a self-declared dreamer, poet, and dog. Kalman has written five books about Max, and these served as the inspiration of Max's Adventures Map. Rereading the stories and making notes of the places Max traveled, learned, loved, and lost helped shape the features on his map and the tone of the books of Max's travels influenced the flavor of his map.

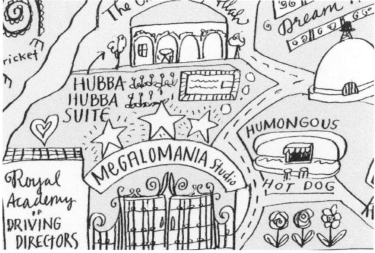

Fig. 2

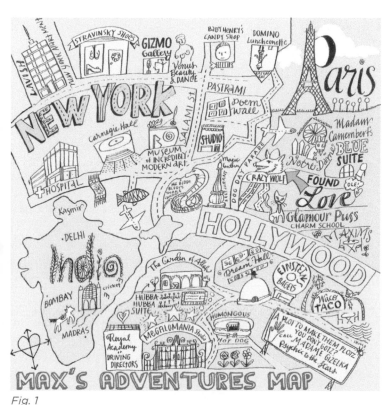

Fig. 1

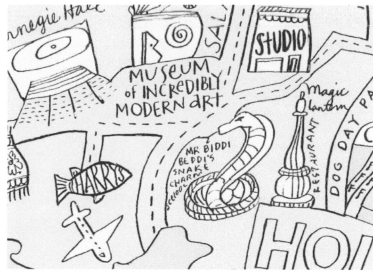

Fig. 3

1. Read through your inspirational material and make notes on the features of the character you are focusing on. Note the tone of the material and things like word usage and illustration style that influence that tone.

2. List the features of the character you want to include.

3. List places the character has gone, and the important things he or she did there.

4. Sketch a map of the character's travels. Don't worry about accuracy. Try to get the flavor of the character's life, using language from the material and the tone of the piece. (Fig. 1, 2, 3)

RESOURCES FOR ARTY CARTOGAPHERS

LEARNING ABOUT MAPS

www.bigthink.com/blogs/strange-maps
www.loststates.blogspot.com
www.handmaps.org
www.learner.org/courses/amerhistory/interactives/cartographic
www.territories.indigenousknowledge.org
www.bigmapblog.com
www.makingmaps.net
www.mapoftheweek.blogspot.com
www.natgeomaps.blogspot.com
www.blog.maps.com/wordpress
www.history-map.com
www.strangescience.net/stsea2.htm

MAP TEMPLATES AND PROJECTS

www.3dgeography.co.uk

DIGITAL MAP COLLECTIONS

Library of Congress Maps
www.loc.gov/maps

Harvard University Map Collection
www.hcl.harvard.edu/libraries/maps/digitalmaps

Huntington Library Digital Map Collection
www.hdl.huntington.org

National Library of Australia
www.nla.gov.au/what-we-collect/maps

British Library
www.goo.gl/bkh6q5

Davie Rumsey Map Collection
www.davidrumsey.com

DIGITAL CARTOGRAPHIC CLIP ART

General
Clip Art Etc.
www.etc.usf.edu/clipart

World Atlas Clip Art
www.worldatlas.com/clipart.html

Cartouches
Decorative Wreaths and Frames, Dover Publications

Ornamental Scrolls and Cartouches (book and CD), Dover Electronic Clip Art

Cartouches and Decorative Small Frames, Edmund V. Gillon, Jr., Dover Pictorial Archives

Sea Monsters
www.strangescience.net/stsea2.html

Treasury of Fantastic and Mythological Creatures, Richard Huber, Dover Publications

1300 Real and Fanciful Animals, Matthäus Merian, Dover Publications

MAP STENCILS

www.artistcellar.com

JILL'S MAP PAGES

Blog: www.personal-geographics.com
Facebook: Arty Cartophiles

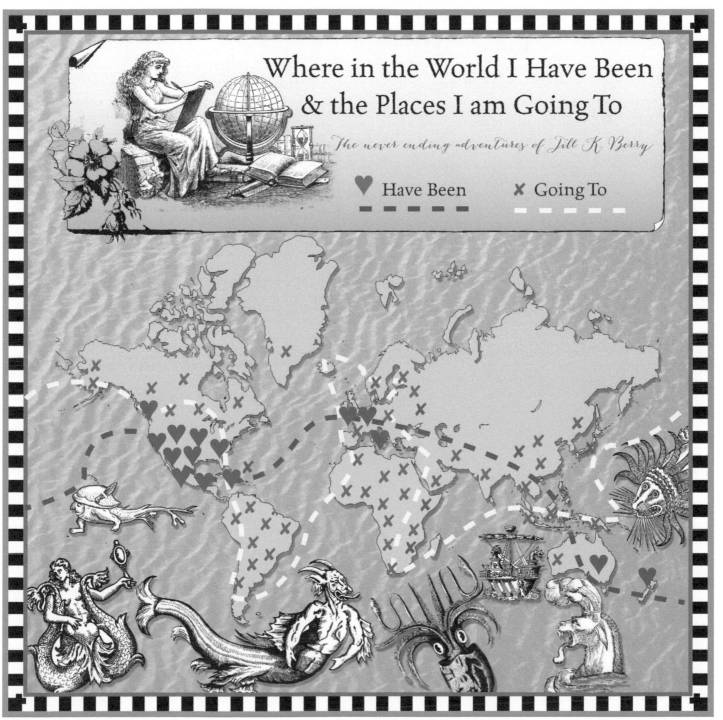

This map is made entirely from the clip art resources listed on this page and combined in a photo editing program, but you could also use these images in a wonderful collage.

CONTRIBUTORS

Baum, Mitsuko
www.mitsukobaum.com

Berry, Sam

Berry, Sydney

Brown, Jean

Canada Mappers
www.mountain.sd41.bc.ca

Clark, Peter
www.peterclarkcollage.com

Coles, Julianna
www.meandpete.com

Corcoran, Sean
www.thearthand.com

Diehn, Gwen
www.real-life-journals.blogspot.com

Famille Summerbelle
www.famillesummerbelle.com

Floyd, Kelly

Gee, Ann Marie
www.annabella67.com

Hall, Theresa
www.sheloveshiny.blogspot.com

João, Lauro Fonte
www.laurofonte.com

Krahulah, Beckah
www.beckahkrahula.com

Kubo, Masako
www.masakokubo.co.uk

Marcum, Laurie
www.greygoddes.blogspot.com

Maxwell, Joanna

Mika, Laurie
www.mikaarts.com

Navajo Nation
www.artsforborderchildren.com

Nugent, Kim Rae
www.kimraenugent.blogspot.com

Rebecca Hossack Gallery

Sloan, Carol
www.carolbsloan.blogspot.com

Smith, Amy Kane
www.amysmithdesigns.com

Taylor, Cathy
www.ctaylorart.com

Thomsett, Michael
www.artpause.com

Winder, Jessica
www.oystersetcetera.wordpress.com

CARTOGRAPHIC CORRESPONDENCE CONTRIBUTORS

John Arbuckle, Pedro Bericat, Katelyn Besin, Adriano Bonari, Traci Bunkers, Matthew Cooper, Diana Darden, Jacque Davis, Jan DeBellis, Consuelo de Biagi, Ingrid Dijkers, Terry Dean Garrett, Jessica Herman Goodson, Alexandria Greer, Uli Grohmann, Penelope Harris, Eni Ilis, Andrea Jay, Trish Johnson, Mel Kolstad, Philip Kuhns, Rupert Loydell, Dòrian Ribas Marinho, Christine Martell, Tammy Murdock, Silvano Pertoni, Morgan Ray, Kara Rogers, Linda Sagastume, Jaromir Svozilik, Simon Warren, Robert Znajomski.

·········· ❧ ACKNOWLEDGMENTS ❧ ··········

Thank you to the many historians, cartographers, and artists through the centuries who could not resist exploring—by land, by sea, and through research and making art—the many ways to map much of what we know in the world. Without the courage of seafaring cartographers, we might still be a continent or two short, and be even shorter still in understanding ourselves and one another. Thank you to our esteemed, patient, and always cheerfully enthusiastic editor, Mary Ann Hall; our industrious and detail-oriented project manager, Renae Haines; and the designer, Leigh Ring, who from the first knew how to make this book beautiful. Thank you to our mom, Joanna Maxwell, who filled the house in which we grew up with things to make, do, and explore, and who continues making things to this day (see her stitched map in Lab 29).

My family supports all of my artistic journeys, and for that I am enormously grateful. Thanks to Sam and Sydney for contributing art and love, and to Steve for making it possible.

—JKB

Thank you to Ian, Phillip, Paul, and Ashlee for never wavering in your support for and interest in this project. Special thanks to Sophia, who was enthusiastic and loved everything I made. And to Tom, whose calm, loving support was always a sturdy shore.

—LMcN

ABOUT THE AUTHORS

Jill K. Berry is an author, teacher, and artist living in the Rocky Mountains of Colorado. Her first book, *Personal Geographies: Explorations of Mixed-Media Mapmaking,* was published in 2011. She thought it would be fun to invite her sister Linden to explore the second book together. She makes artists' books, paintings, maps, and other storytelling structures, and her work has been published in many books and magazines. She teaches her techniques worldwide.

(Photo credit: Steve Berry)

Linden McNeilly is a writer and teacher living in the Monterey Bay area of California. She loves making things and teaching kids to knit, draw, dye textiles, paint on silk, and make beaded projects. She received her master's in fine arts from Vermont College of Fine Arts and is presently at work on several middle-grade novels with quirky characters and a touch of magic. Working with her sister, Jill, has been a privilege.

(Photo credit: Sophia Tatum-McNeilly)

CPSIA information can be obtained
at www.ICGtesting.com
Printed in the USA
LVHW01s2346160218
566754LV00013B/14/P